Chinese Ceramic Glazes

Chinese Ceramic Glazes

BY A. L. HETHERINGTON

SOUTH PASADENA : P. D. AND IONE PERKINS

NK
4165
H345

WITHDRAWN

CONTENTS

PLATES

PREFACE TO THE AMERICAN EDITION

*O*WING TO THE difficulties under which printing and publishing in this country are still operating, the opportunity offered for an American and up-to-date edition of this book has been taken. There is the further justification that the demand for the book in the United States has been as great as, or greater than, in this country. The students of Chinese ceramics in America apparently show more interest in the scientific explanation of the various glaze effects produced so wonderfully by the Chinese than do their fellow collectors on this side. Perhaps their outlook is more realistic.

Although written principally as an attempt to link up science and archaeology in this particular field for the interest of the collector, potters have shown much interest in its contents and have found therein pointers of use to them in their work.

<div align="right">A. L. HETHERINGTON</div>

March 1947

PREFACE

THIS LITTLE BOOK attempts to convey, in as simple language as possible, the underlying scientific principles on which depend the chief glaze effects produced by the Chinese potters from the Han to the Manchu dynasties, a period extending over some 2,000 years. The account does not pretend to be exhaustive, for to make it that would involve explanations of a nature which would not be readily acceptable to the general body of collectors. On the other hand, collectors often desire to know in general terms how a glaze is made, to what the color is due and why glazes in one period are so different from those in another. Moreover, there are various characteristics, known to connoisseurs, which would be still more interesting in the light of a scientific explanation of how they arise.

The account given should furnish answers to many such questions, and it attempts to link up scientific facts with archaeological knowledge. The substance of what is here contained is a restatement of a series of lectures I was invited to give at the Courtauld Institute in February of this year and this book is being published at the conclusion of the lectures in order to amplify them in certain respects.

I must express in no measured terms the great assistance I have received from several persons, but particularly from two. I was privileged some years ago to take part in in-

vestigations made by the late Sir Herbert Jackson, F.R.S., into the chemistry of many of the Chinese glaze effects, and much of the contents of this book is based upon that work in which in the main I played the role of an observer. The other person to whom I owe a very great debt of gratitude is Dr. J. W. Mellor, F.R.S. His name as an authority on ceramic matters from a scientific point of view is known all over the world and his contributions on the subject in the *Transactions of the Ceramic Society*— several of which are referred to herein—are outstanding additions to knowledge. He has been good enough to allow me to consult him on all points and has been to the trouble of reading and commenting on my text. Not only that, but he has also been moved to conduct certain additional researches to clear up aspects which were in doubt.

I am further indebted to him and to the Council of the Ceramic Society for being allowed to include certain illustrations that have appeared in their *Transactions*.

I am also beholden to my old friend Bernard Moore. He was a distinguished potter with great scientific insight as well as technical knowledge, whose death deprives all concerned of a source of material assistance.

Professor W. Perceval Yetts has been to much trouble in checking the spelling of the Chinese names and ensuring that they are in the most recently accepted form.

A. L. HETHERINGTON

January 1937

GENERAL CONSIDERATIONS

*C*HINESE CERAMICS can be approached and studied from several different angles. The most interesting, or at all events the most popular, is from the aesthetic standpoint, and most that has been written on the subject for the help and guidance of its students is based upon archaeological researches, coupled with the scrutiny and translation of Chinese texts.

The approach in this little book is from a different point of view, the scientific one. Most people who are interested in the subject know the general story of Chinese ceramics and have seen many examples dating from the earliest times down to the nineteenth century, of which all but the latest work was displayed in profusion at the Chinese Exhibition at Burlington House in 1935-6. Our museums have notable collections where students can study shapes and general characteristics, while a range of books of an authoritative nature on those aspects can be consulted. On the other hand, little has been written about the scientific aspect of Chinese ceramics, at all events for the particular information of collectors of the wares. One reason perhaps is that it is difficult to make the chemistry and physics of glazes intelligible and interesting to those who do not possess much

technical knowledge. It is not easy to explain adequately the factors that have operated to bring about certain effects without plunging into a mass of technical detail which leaves the reader even more puzzled than at the outset. But that is no reason why an attempt should not be made.

A wide range of glaze effects was produced by the Chinese potter over the long period of time extending from the Han dynasty down to the time of the Manchus, and it is well to record at the outset the great technical knowledge displayed by the Chinese potter. The more the glaze effects produced in early days are examined scientifically, the more impressive becomes his knowledge. He may not have used the jargon of the scientist of today but he obviously approached his task in a scientific fashion. His power of observation and deduction went near to what we term scientific method, and his close repetition of previous processes, arising from observation, helped him to produce what today is admired so much. Probably many of the well-known glaze effects were brought about by accident rather than by design in the first place. Something went wrong and an entirely different result was produced in the place of the expected. If the appearance was pleasing, the potter noted it and tried to repeat the accident: he probably failed in the attempt or obtained only a partial success; but further trials led to a mastery of the process. There is a good deal of evidence that this was so, although we need not place

too much importance on the legendary account of how the potters of Chi-chou fled in terror because their wares turned suddenly into jade during the visit of a high official: or on the story of how the potter T'ung threw himself into a kiln in despair of executing an Imperial order, to bring about miraculous results and his own deification in consequence.

Potters of today look forward with excitement to the "drawing" of a kiln. A great variety of effects may be produced by relatively small and chance variations in the conditions inside the kiln and the potter can never tell with certainty what will have been the result. The most skilled potters may have to fire a hundred pieces in order to get one or two specimens of the special effect they seek. The object of this book is to try and explain some of the chief underlying facts that determine how different glaze effects come about and to describe in a measure the host of factors which come into play to cause the varying results that arise.

Nature of a Glaze

The first thing to realize is that a glazed vessel consists of a pottery or porcelain body over which has been laid a layer of glass; and glass is to be regarded as a super-cooled liquid which under stress of heat becomes fluid again and can flow readily. If a piece of bread were spread with a thin layer of butter upon it, an analogy to a piece of thinly glazed pottery or porcelain would be furnished. If a spoonful of

syrup or treacle were smeared upon the piece of bread, the counterpart of a thickly glazed vessel, such as those found in the Sung wares, would be produced. Butter in hot weather becomes "runny" and syrup is more fluid when hot than when cold. Human beings exist best in a temperature at which glass is apparently a brittle solid and not a liquid. Pitch is another example of a super-cooled liquid which is a brittle solid at low temperatures.

It will be convenient to group the glazes to be described into two main classes, the felspathic glazes and the lead silicate glazes. The former are made from materials rich in felspar, a mineral widely distributed in the world and consisting of silica, alumina and alkali in combination. It is an essential ingredient in the Chinese *petuntse* or "little white bricks," so called because the felspathic rock was pulverized finely, washed in water and finally converted into a smooth white paste which was made up into small blocks for the potter's use. *Petuntse,* like our Cornish stone, consists roughly of one-third felspar, one-third white clay and one-third quartz. Père d'Entrecolles, in his well-known letters, says the Chinese potters liked *petuntse* which showed cypress-green streaks. Similar streaks occur in some varieties of Cornish stone. The felspar glaze material, used centuries before Père d'Entrecolles' time, was similar but less carefully prepared and refined.

A glaze consisting almost entirely of felspar is somewhat difficult to melt or fuse and there-

fore to manipulate: it was put on the body thickly in the early days before the potter had learned to cope with it satisfactorily by modifications of the ingredients of the glaze and of the firing conditions. Later, the potter learned to handle it more readily and found no difficulty in applying it thinly. Even in some of the Sung wares this type of glaze is found in very thin layers. The difficulty of their application arose not so much from the fact that they were hard to fuse, but because they had a high viscosity. Being viscous or treacly in consistency, they flowed very sluggishly when fused, and the glazes were thickly applied to lessen the risk of imperfections or loss arising from unhealed scars and the like. Incidentally, a depth was obtainable that would have been impossible with a thin and watery glaze, unless the latter was fused gently and for a long time at a comparatively low temperature. The length of time of heating a glaze is an important factor in getting it clear, for the slow fusion of the ingredients causes the disappearance of solid particles which by their persistence would cause a scattering of light and consequently a cloudy effect. If lead oxide is introduced, the glaze can be matured at much lower temperatures and, as fluidity is more rapidly secured and maintained, a thinner layer of it can be more easily obtained in the melted condition. These less viscous lead-silicate glazes were used in the pre-Sung wares. They were replaced by the viscous felspathic glazes in that dynasty but were re-employed

later. They were used extensively as fluxes for on-glaze colors or enamel colors, superimposed on a groundwork of glaze of a felspathic nature. These enamel glazes were fired as a second operation at a lower temperature in what is called a muffle kiln.

The glaze is applied to the body in the following way. The glaze mixture, before being mixed with water to form a fine suspension, is prepared by one of two methods. The ingredients may be ground up together and mixed in that fashion. The glaze mixture is then termed "raw." Or, as is more commonly done in modern practice, the intimacy is heightened by fusing them together in a frit kiln with considerable heat and then pulverizing the glassy product subsequently. This latter method is called "fritting," and the product is called a fritted glaze. Felspar might be called "Nature's frit."

The Chinese potters, however, did not use fritted glazes, at all events until recent times. They used raw glazes. Fritting was introduced into this country as a result of a report by Thorpe and Oliver in 1898 to overcome lead poisoning of operatives when preparing lead silicate glazes.

The vessel to be glazed is then either dipped into the suspension or brushed over with it, or the suspension is sprayed on to it. After the vessel has been dipped in the glaze, the porous body sucks up the water and leaves behind a film of the glaze which previously was suspended in the water.

Plate I. A Chinese kiln.

The vessel will have been previously thrown on the wheel and subsequently sun-dried in the case of the earlier more primitive bodies, or lightly fired in the case of the later porcelain bodies. Naturally the sun-dried vessel was of a stouter nature to give the necessary stability to the shape, whereas the vessels which were biscuited, as it is termed, in a kiln could be made much thinner. In either case, the vessel with its layer of fritted glaze evenly spread over the body was placed in a saggar or protective case and fired in a kiln which was fed with wood as fuel. The high temperatures required were secured by what is termed an induced draught. The kilns were usually situated on a hillside where the slope of the ground furnished the necessary draught. Plate I is a photograph of a Chinese kiln operating today. The heat of the kiln first drove off all the moisture and then fused the glaze ingredients so that the vessel became coated with a layer of molten glass or glaze.

Nature of Bodies Used

Before going further it will be well to make a slight digression and say something about the different bodies used by the Chinese potters. In the Han and T'ang dynasties, the bodies consisted of clay which was hardened in the fire after the glaze had been applied in the suspended condition. The lead-silicate glazes employed at that time fuse at a relatively low temperature and the body in consequence was not high-fired. Sometimes the bodies of these

early wares are soft enough to be scratched with a knife while others resist the treatment. The glazes no doubt varied somewhat and some fused at lower temperatures than others; further, the nature of the clay varied in different localities where the early factories were operating. It is known from the early literature that centres of ceramic production were established all over China in a widespread fashion in those times and all of them were making similar types of ware. It is easy to prove that the hardness of these early bodies is due in large measure to the degree of heat applied, for if a piece of T'ang ware, the body of which yields to a knife, is refired at a fairly high temperature, the body will become quite hard and will then resist the knife.

The earthenware bodies, consisting of clay with an admixture of such a material as quartz, gave a stouter material than a simple clay, and they were largely used in the T'ang dynasty. They were replaced by the stoneware bodies which were similar in nature. These were continued until the time arrived when an approximation to true porcelain was reached. These early porcelain bodies contained *kaolin* or china clay mixed with felspar, and it is known from the evidence of the Samarra fragments that bodies of this nature were freely made in China as early as the T'ang dynasty. The European and Chinese definitions of porcelain differ. We regard translucency as the determining test, whereas the Chinese attached more importance to whether the vessel rang when

flicked with the finger. Some of the Samarra fragments will satisfy both definitions.

Kaolin in a pure state is a natural compound which contains alumina, silica and water, and it varies considerably in composition in the different localities where it is found. When it is mixed with felspar and fired, the latter melts and vitrification takes place through the body with the result that a translucency is imparted to a degree varying with the composition of the mixture and with the temperature applied. Even without the addition of felspar, a porcelain (in the European sense of the term) can be made from finely-divided kaolin, if it is heated to a sufficiently high temperature. The dividing lines between earthenware bodies, stoneware and porcelain are not nearly so clearly marked as popular opinion holds. It is possible to make a stoneware body, so called, transmit light if potted thinly enough and if the firing conditions are appropriate both as regards the degree of temperature employed and, equally important, the length of firing-time. There is a time reaction as well as a temperature reaction, and it is possible to produce at a relatively low temperature effects similar to those obtained at high temperatures if the firing time is sufficiently increased. The addition of the felspar assisted the vitrification process very much and allowed the process to go on at a lower temperature than would otherwise be required.

The close relationship between china clay (*kaolin*) and china stone, or *petuntse* as the

Chinese call it, is not always appreciated. Felspar and felspathic rocks, like some of the granites, are susceptible to weathering, and when they disintegrate and become friable, they gradually break down and form china clay. The action is naturally a very slow one, but china clay is essentially decomposed felspathic rock. The alteration consists in the removal of alkalis and the formation of a hydrated silicate of aluminum, having the formula $Al_2O_3.2SiO_2.2H_2O$.

When a felspathic glaze is put on a stoneware body and fired, it will be found at the point of juncture that vitrification of the body has taken place, and it is legitimate to surmise that observation of this fact had a good deal to do with the production of porcelain as we term it. The Chinese potter may have observed from a broken vessel this layer of vitrified body under the glaze and noted how the glaze had eaten into the body, so to speak, to give a more or less translucent layer. He may have said to himself: "Why not put some of the glaze stuff (felspar) into the body and make that thin layer spread throughout the vessel?" The evolution of porcelain may have been initiated in some such way, especially when it was found that by using purer and more finely divided clay material the operation was improved.

Slip

Clay was used for purposes other than making bodies. It was mixed with water to make a

luting material for joining sections of a
vessel together. Larger vessels were more
easily fashioned, if thrown in sections and sub-
sequently built up by joining the sections to-
gether with this mixture of clay and water.
In a thin suspension of clay in water a cream-
like liquid is formed which is called "slip."
This slip was used as a decoration either
with or without coloring matter; many of the
early white wares owe their effect to a thin
opaque white coating of slip with a transpar-
ent glaze superimposed upon it, providing as
a result a beautiful creamy-white glaze. The
Tz'ǔ Chou wares furnish good examples of the
use of slip to produce this white effect and for
decoration in a variety of ways. In Europe slip
decoration is common enough. This clay sus-
pension or slip can easily be run into moulds
porous enough to absorb the excess moisture.
In this fashion very thin vessels can be made,
and in large quantities by mass production.
The Chinese potter apparently did not use
this moulding process to any large extent and
depended on the wheel and his fingers for his
shapes. That he was able to obtain excessively
thin bodies by means of his wheel and paring
tools is proved by the egg-shell bodies of which
he was a master.

Scattering of Light in a Glaze

There are a number of reactions of a chemical
and physical nature which it will be conven-
ient to describe in order to make later refer-
ence to them easier. Bare mention has already

been made of the cloudy effect in a glass or glaze due to the scattering of light from unfused particles contained in it. Scattering of light may be explained thus. A sheet of paper is composed of a mass of fibres of cellulose derived from wood or rags. These fibres interlace at various angles to each other. The paper looks white by reflected light and is fairly opaque by transmitted light. That result is due to the fact that light is being reflected from the fibres set at a variety of angles to each other. If the interstices were all filled up, and a homogeneous layer produced in consequence, the light would not be reflected back to the eye. The paper would look dark instead of white by reflected light and become much more transparent by transmitted light. The interstices could be filled by adding water or oil to the paper and the light would cease to be scattered. Or again, if a sheet of transparent glass is rubbed with emery paper, the transparency will disappear and a piece of ground glass will result. The light will be reflected from the intersecting roughnesses created instead of passing through. If the roughened glass is wetted, the tiny hills and valleys will also be temporarily levelled up and the glass will become transparent or nearly so.

If there are a number of particles of opaque material imbedded in the glass or if there are minute bubbles in the glass, light will be reflected back from their surfaces and a cloudiness or opacity results. The soft appearance of the early celadon glazes is caused in this way

and the difference in them from the Ming celadons (or the Northern Chinese celadons), which are usually clear, is marked.

Oxidation and Reduction

Reference will be made shortly to the oxidation and reduction of glazes and it is necessary to make clear what is meant by those terms. The coloring materials used in the Chinese glazes are derived from certain metals, united as a rule with oxygen: when a metal is so united, the compounds formed are called oxides. Metals may join with oxygen in more than one proportion and so a series of oxides is produced. Thus, the two chief oxides of iron are ferrous oxide (FeO) and ferric oxide (Fe_2O_3). A combination of these two oxides is the magnetic oxide of iron (Fe_3O_4), which is sometimes called ferrosic oxide, a name which it is convenient to use in dealing with such a combination in glazes. Again, copper forms two oxides, cuprous oxide (Cu_2O) and cupric oxide (CuO).

All the metals unite with oxygen to form oxides, but the two metals taken as illustrations are responsible for the greater part of the coloring effects used by the Chinese for their glazes; and, so far as the early glazes are concerned, are responsible for more than 90 per cent of them. It will be noticed from the formulae that the proportion of metal to oxygen varies; ferrous oxide (FeO) contains a higher proportion of iron than does ferric oxide (Fe_2O_3); and cuprous oxide (Cu_2O) a higher

proportion of copper than cupric oxide (CuO). It is obvious that the amount of oxygen in Fe_2O_3 or in CuO might be reduced to form the lower oxides, FeO and Cu_2O; or that the amount of oxygen might be reduced still more until it was taken away altogether, when the metal would be left by itself. The process by which that is done is called reduction. Alternatively, it is possible to start with the metal and work up, adding more and more oxygen to form the series of oxides mentioned. That process is called oxidation.

How are the processes of oxidation and reduction brought about in a glaze? The metal and oxygen in an oxide are held together by their affinity for one another. If, however, we were to introduce something that had a greater affinity for oxygen than the metal has, the oxygen (or part of it) would forsake the metal and take up with this other something for which it had a greater liking. The metallic oxide would either be reduced to its lower oxide or be robbed of all its oxygen until the metal was left all alone.

Carbon monoxide (CO) is greedy of oxygen and is always trying to convert itself into the higher oxide of carbon—carbon dioxide, CO_2. The union can be quite violent, for if carbon monoxide is mixed with air or oxygen and a light is applied to the mixture, it will explode to form carbon dioxide or carbonic acid gas. Not only does carbon monoxide seize oxygen from the air whenever it gets a chance but it will rob an oxide of its oxygen if it possibly

can. Now if charcoal is heated in a limited supply of air, carbon monoxide is formed and can be introduced into a kiln where a glaze containing ferric oxide or cupric oxide is being fired. The carbon monoxide will capture as much as it can of the available oxygen in the metallic oxide and will reduce the latter.

The carbon monoxide was introduced in the following way. Wood smoke, which consists of finely divided particles of carbon, was allowed to enter the kiln. With the limited supply of air present, the particles of carbon formed carbon monoxide and so created what is termed a reducing atmosphere. The process would also produce hydrocarbon gases, as well as carbon monoxide, and these are also powerful reducing agents.

Another method which was apparently employed at Ching-tê Chên in the Manchu dynasty was more elaborate. A special form of saggar or protecting case was used which was perforated with a number of holes. The perforated saggar was placed in another saggar without holes and the space between the two saggars was filled with charcoal. On firing, the charcoal formed carbon monoxide by uniting with the limited supply of oxygen present. The carbon monoxide thereupon passed through the perforations of the inner saggar, seized oxygen from the oxide in the glaze covering the vessel in the inner saggar to form carbon dioxide and left the metallic oxide in a reduced condition.

An interesting example of the different effects caused by reducing and oxidizing atmospheres can be furnished by firing two exactly similar pots in the two different types of atmosphere and by studying the result on the iron oxide contained in them. It should be explained that iron is a singularly ubiquitous metal: it crops up everywhere, and one of the aims of the potter is to free his substances from iron unless he wants it there. Even after great trouble has been taken to get rid of iron, minute quantities almost invariably remain. If two pots, each made of exactly the same material for the bodies and with precisely the same glaze material, were fired, one in a reducing atmosphere and the other in an oxidizing one, the result would be to produce a glaze with a cold bluish tone in the first case and the pot fired in the oxidizing atmosphere would have a warm creamy tone. The difference would arise from the fact that the reducing atmosphere would have turned the minute quantity of iron present into the greenish ferrous oxide and the oxidizing atmosphere would have converted it into the yellow ferric oxide.

The Chinese porcelain was generally fired in a reducing atmosphere and the cold bluish-green tone of the Chinese porcelains is accounted for in that way. On the other hand, the English bone china is more commonly fired in an oxidizing atmosphere and, as a rule, presents a creamy appearance.

A further method by which a reducing effect might be produced in a glaze arises from the action of one metallic oxide upon another. Ferrous oxide (FeO) has an affinity for oxygen and is always wanting to convert itself into ferric oxide (Fe_2O_3). Its liking for oxygen is greater than that of copper for oxygen; and so, if cupric oxide (CuO) and ferrous oxide (FeO) are both present, the latter will rob the former of its oxygen to convert itself into ferric oxide and will leave the cupric oxide either in the form of the lower oxide, cuprous oxide, or reduce it still further to leave copper only. This latter stage is what usually takes place in the case of cupric oxide, and the intermediate stage of cuprous oxide (Cu_2O) seems seldom to be reached and maintained in a glaze. Complete reduction generally takes place. The advantage of such a reducing method would be that a local reduction could be effected by means of it. Obviously the formation of a reducing atmosphere, such as that obtained by the first two methods mentioned, would affect the whole of a molten glaze exposed to its action and it would be very difficult to localize the effect. On the other hand, this ferrous-oxide method would affect only the portion of the glaze in immediate juxtaposition. The ferrous oxide might be manipulated in one of two ways. A smear of slip or glaze containing ferrous oxide could be placed upon a body, or a design could be placed on the body by means of such a slip or glaze. The vessel could then be coated all over with a

glaze containing cupric oxide. On firing, the ferrous oxide would seize the oxygen from the cupric oxide in the glaze in immediate contact with it, but the cupric oxide in the rest of the glaze, not being in the presence of a reducing agent, would be unaffected.

A similar result could be achieved by covering the vessel as a whole with a glaze mixture containing cupric oxide. The design could then be executed by removing that glaze and substituting for it in the spaces left another glaze containing cupric oxide mixed with some ferrous compound or an equivalent reducing agent. The splash or design of different color would, on firing, be localized to the portion of glaze where the ferrous oxide, or other reducing agent, was present.

Some evidence of this reducing effect by ferrous oxide will be familiar in the case of the spotted celadon, or buckwheat celadon, called by the Japanese *tobi seiji*. Occasionally that effect takes the form of dark splashes on the celadon background but with a ring or halo of red surrounding the splash. As a rule, the dark splashes arise from ferric oxide in a surrounding green ferrous glaze; but in the type referred to, the dark splashes are due to cupric oxide. On firing, the surrounding ferrous glaze attacks the spot of cupric glaze where it can get at it, viz. the periphery of the spot. At this point the ferrous oxide reduces the cupric oxide and brings about a ring of reduced copper; but the center of the spot is unaffected and retains the characteristic color of cupric oxide.

The Effect of Acids and Alkalis in a Glaze

The differences that arise in the coloring effect of glazes by the presence of acidic and alkaline constituents and by varying their proportions are important, so that some reference to the subject is necessary as an introduction to a description of the series of iron and copper glazes which will be dealt with at length later. It is hardly necessary to explain the difference between an acid and an alkali or base, or to say that the chemical combination of the two results in the formation of a salt. All glazes contain acidic and alkaline constituents, but the proportions in which these are present determine to a very large extent the character of the glazes and the readiness with which they fuse or melt. So far as the Chinese glazes are concerned, the main acid constituent is silica (SiO_2). Alumina or the oxide of aluminium (Al_2O_3), which is also present in the felspathic glazes, may be considered as functioning to some extent as an acid but also as a base. The alkalis and other bases found are the oxides of the metals, sodium (Na_2O), potassium (K_2O), calcium (CaO) and lead (PbO).

Bases	Intermediate	Acids
Sodium oxide, Na_2O	Alumina, Al_2O_3	Silica, SiO_2
Potassium oxide, K_2O		Boric oxide, B_2O_3
Calcium oxide, CaO		
Lead oxide, PbO		

Apart from the colouring materials, the other chief constituent which should be mentioned as being sometimes found in Chinese glazes

is calcium phosphate $Ca_3(PO_4)_2$, which is a salt.

Speaking generally, if the proportion of the acidic constituent is high, the glaze requires a high temperature to fuse it; if the basic constituent is high in amount, a lower temperature will be needed for fusion. It has already been stated that the felspathic glazes require a high temperature for their fusion and that the lead-silicate glazes are more readily melted. The felspar commonly used for glazes is a double silicate of potassium and aluminum, and the potassium is often replaced by sodium. These felspathic glazes are consequently rich in the acidic constituent, silica, and as a result require a high temperature. They can be made more fusible by the introduction of a small proportion of an extra base such as calcium oxide in the form of calcium carbonate, chalk. It will thus be realized that a considerable variety of felspathic glazes can be made, which alter in their fusibility with differences in the proportion of their acidic and basic elements. Further variations were brought about in making glazes by adding to the felspar finely ground quartz (silica), together with alkalis and lime, and so yielding a glaze fusible at a reasonably low temperature. While if lead oxide is substituted for lime, a still lower temperature would serve for fusion. In the purely lead-silicate glazes, the requisite silica is obtained from quartz.

Apart from the difference in temperature required to fuse these varying types of glaze,

the differences in viscosity are important. The high-temperature glaze will have the fluidity of a thin syrup. The viscosity of a glaze plays an important part in certain color effects derived from the metallic oxide bringing them about, because the dispersion of metallic oxide through the glaze is hindered by the treacly medium containing it. The sluggish flow of a felspathic glaze is readily realized by recalling the thick rolls of glaze near the foot-rims of some temmoku bowls or the "tear" drops on a Ting bowl or plate. These glazes have great artistic qualities of their own and owe much of their depth of color to their high viscosity. Glazes of this character can be applied in thick layers: as a result a richness of color can be achieved which would be impossible in a thinner glaze of the same composition. It is only necessary to recall the difference in color between masses of water of varying depths to realize how the thickness of a mass affects its ultimate color. The distinctive features of many of the Sung glazes are largely due to these facts.

The high temperature required for maturing these glazes tended to the incomplete fusion of some of the glaze ingredients. The requisite temperature was not always reached and maintained for a sufficient length of time, with the result that unmelted particles remained to cause scattering of light and a cloudy and soft appearance. Moreover, bubbles of gas, created during the process of fusion or from reactions during the firing,

were not able to rise to the surface and dis-
perse. As a result they became imprisoned in
the glaze to furnish further sources of scatter-
ing. The more fluid lead-silicate glazes had
very different qualities: their lower viscosity
and the thin layers in which they covered the
body surfaces made other effects possible, but
they did not furnish the means of displaying
many of the characteristic qualities of the
more refractory felspathic glazes.

THE IRON STORY *WE ARE NOW*
in a position to begin an examination of the
main glaze effects produced by the Chinese
potter and of the wide range of colors made
by him. Practically all of the earlier color
effects were secured by the use of only two
metals, iron and copper. The ingredients of
the potter's palette were limited at that date,
but the manifestations he brought about were
varied. It is astonishing what a host of colors
can be achieved from iron and copper alone
when added to a glass or a glaze under suit-
able conditions, and it is necessary to study
with care the factors which come into play in
order to produce the results. We will start
with iron, for the iron story is a long and inter-
esting one. There are two chief oxides of
iron, ferrous oxide (FeO) and ferric oxide
(Fe_2O_3), the proportion of oxygen in the
latter being greater than in the former. The
presence of iron in the ferrous condition gives
rise to colors ranging from light green through
shades of blue-green to a fairly intense green,
according to the amount of ferrous iron pres-
ent and to the nature of the glaze in which the
ferrous oxide is held. The common green
bottle owes its color to the glass containing
ferrous iron.

Iron in the ferric condition gives rise to a still wider range of colors varying from a pale yellow, through deeper shades to a brown and a red-brown of various tones, to a depth of color to give the appearance of black to the unaided eye.

There is another oxide of iron arising from a mixture or a combination of the two oxides already mentioned. It is sometimes called ferrosic oxide (Fe_3O_4) and is also termed "blacksmith's scale."

Ferrous Oxide

Taking the glaze effects due to the presence of ferrous iron we have the whole range of the celadons and related wares. The name celadon —the origin of the name celadon will be found in the Glossary—denotes a color ranging from light green through a blue-green to an olive-green, with further tones of dove-grey. These colors are due to iron, predominantly in the ferrous condition. If either intentionally or accidentally in the furnace, a glaze intended to be a ferrous glaze becomes oxidized, it may be oxidized wholly or in part. If partly, there will be a mixture of ferrous or ferric oxide and the color will change from the ordinary light green to a dark olive-green or even almost to a black color. The olive-green celadon glazes which are associated with the group of wares termed "Northern Chinese celadons," for lack of a more precise knowledge of their provenance, are familiar examples of this type. Specimens of indifferent celadon in which the green glaze has become

discolored with passages of brown color, marring the general effect, are also common to find.

The color produced by ferrous iron in glazes will vary with the composition of the glaze and to a large extent also with the temperature at which the glaze is fired. But assuming that all the iron is kept in the ferrous condition—and this condition is by no means an easy one to maintain in practice, having regard to furnace conditions and to the difficulty of preventing completely the presence of an oxidizing atmosphere—it yields in this condition either a green or a blue-green tint to a glaze.

The presence of different alkalis or bases produces somewhat different tints with the same percentage of ferrous iron in the glaze. In glazes where the basic portions are sodium oxide and lime, or potassium oxide and lime, or where the lime is replaced by lead oxide, marked differences in color-tones with the same percentage of ferrous oxide are obtained. It is hardly surprising therefore to find celadon glazes with considerable differences in color, some appearing to the eye to have an appreciable blue tint and others a definite green.

Further, the effects of scattering of light from unfused particles or from minute bubbles must be taken into account. The introduction of a cloudy effect necessarily has a result on the ultimate color. The addition of milk to black-currant juice alters considerably its

appearance; and the green color in a glaze is modified by the introduction of what, in effect, is the addition of a white color. Certain books on Chinese ceramics have suggested that the blue tone of the *kinuta* celadons is achieved by what is described as "a pinch of cobalt." It is impossible to know what is meant by "a pinch," and a sufficiently large specimen of *kinuta* celadon has not been destroyed and analyzed in order to determine whether there is, or is not, any minute quantity of cobalt present. It is highly improbable. Moreover, the blue tone in question can be obtained by the employment of ferrous iron only in a suitable glaze and under appropriate firing conditions. At the Chinese Exhibition at Burlington House there were some good specimens of the blue *kinuta* celadon, but it is more than doubtful whether the potters who made them employed any cobalt to produce the effect.

The suggestion has been made that possibly there may have been in some of the materials used a trace of a metal, called lithium. That metal in a ferrous glaze gives a blue color. It is possible that some of the prized bluish celadons may owe their distinction to a trace of lithium impurity. This is speculation but in certain specimens of celadon glazes traces of lithium have been detected by spectroscopic analysis. Père d'Entrecolles in his letters speaks of the best stone from which *petuntse* was made as having a slight tinge of green. This was probably due to traces of lithium-

mica. But he does not mention the point especially when describing the celadon glaze.

In this connection mention may be made of the *ying-ch'ing* ware, that highly translucent porcelain, dating from Sung times, with a shadowy-blue glaze from which the ware derives its name. The blueness of the glaze has been investigated* by spectroscopic methods by placing small pieces of the glaze in an electric arc between purified carbon electrodes and examining the light from the arc by means of a spectroscope. The spectrum of lithium was clearly seen and persisted during the whole of the volatilization of the glaze fragments.

While these spectroscopic investigations prove the presence of lithium, it should be recorded that work done at the North Staffordshire Technical College on lithium compounds in glazes, particularly lepidolite, has shown it difficult to develop blue shades in glazes from this source. An alternative suggestion is that the *ying-ch'ing* blue is due to ferrous phosphate. The Sung glazes almost invariably contain phosphate and in a reducing atmosphere are likely to develop traces of ferrous phosphate which is blue, as for example in the mineral vivianite.

In the case of the celadons in which the green tint approaches to an olive or even a brown-olive, there is little doubt that the furnace conditions were such as to produce a

Vide paper on ying-ch'ing porcelain by Sir Herbert Jackson, *Oriental Ceramic Society Transactions,* 1926-7.

small amount of oxidation. It is reasonable to assume that the brownish-green or greenish-brown celadons owe their color to oxidation, mainly during the initial stages of the firing before the glaze melted. On the other hand, the effect of aerial oxygen on a molten glaze cannot be ignored, and Dr. Mellor has drawn attention to the considerable effect that may be created by its presence, even in relatively small quantities. But in the thick felspathic glazes the penetration of the aerial oxygen would be less.

Reference has already been made to the "soft" effect in the celadons, due to the scattering of light by unmelted particles or by minute bubbles in the glaze. The Ming celadons are much more transparent and have not this cloudy effect as a rule. In the Ming days it was probable that the technique of the potters was more advanced. The firing conditions were under better control and the glazes were more completely fused or else lower-fusing glazes were employed. It is interesting to note, however, that the Northern Chinese celadons are very "glassy" as a rule, and these date from Sung times. They are also much thinner than the usual celadon glazes. Probably higher temperatures were used for the Northern celadons and this would account for the more complete fusion of the glaze ingredients. Some confirmation is furnished by the stability of these glazes. Buried specimens have been found in which little or no disintegration has taken place after centuries of

exposure to the action of the damp earth. Generally speaking it may be stated that a high-fired glaze is less susceptible to later chemical influences than are those subjected to lower-firing conditions at the time of manufacture.

The main points to note in the case of the celadon glazes are:

(*a*) They owe their color to the presence of iron, mainly in the ferrous state.

(*b*) The differences in color-tones are due to one or more of the following conditions: (1) The nature and proportions of the bases present in the glaze. (2) The extent to which oxidation has taken place. (3) The thickness of the glaze and the sense of depth imparted in consequence. (4) The firing temperature, the time of firing and the rate of cooling.

(*c*) The "softness" of color in certain of the celadons is due to the scattering of light, resulting from the presence of bubbles and/or of numerous particles of semi-fused quartz and partially fused glaze frit; and also to minute crystals which have formed during the maturing of the glaze.

These considerations seem to explain satisfactorily most of the varieties of celadon effects that are familiar to us, and they also account for the slight variations in color presented in the same specimen. Just as a finely figured piece of wood is more pleasing to the eye than a homogeneous panel, so passages and gradations of color in a glaze furnish distinction. That is why the early celadons are more

attractive artistically than the later and more "glassy" specimens.

The Sung potter, either through lack of technical experience or *per contra* through the possession of greater technical dexterity and artistic appreciation, produced, as a rule, a celadon glaze which is opaque in its appearance to the unaided eye. From one point of view these pre-Ming glazes display the artistic qualities of their technical defects; and it is interesting to speculate whether the Sung potter was not indeed the master of the technique displayed by his Ming successor but did not employ that technique by reason of his greater artistic appreciation. It is more likely, however, that the earlier potter—at all events in the center of ceramic production where the Sung celadons were largely made, viz. Lung-ch'üan—employed temperatures and batch mixtures which were not likely to produce the clear transparent celadons of the Ming potters. We know that in the Ming dynasty the Lung-ch'üan potters moved to a nearby area—Ch'u-chou—and there produced a similar type of ware but of a more glassy appearance.

The "Iron-Foot" and "Brown-Mouth"

It may be appropriate here to make some observations on the "brown mouth and iron-colored foot" which are associated in the Chinese literature with several of the early wares, among others with the Lung-ch'üan celadons. The iron-colored foot, which varies in color from a lightish brown to brick-red, is gener-

ally explained as due to a considerable amount of iron in the body which has burnt red in the firing. This explanation needs some qualification. The glaze of the ware, as we have seen, owes its color to iron in the reduced condition and is brought about by a reducing atmosphere; the red color on the exposed foot and mouth-rim is due to iron in the oxidized condition; and there would appear to be a conflict of argument at first sight, since the ware was fired at one and the same time.

The main part of the firing was done under reducing conditions and the iron was consequently reduced to the ferrous and green state. At the conclusion of the firing the reducing atmosphere in the kiln was swept out by the admission of air and the oxygen in it reacted on the extremely hot and exposed body to oxidize the iron in it to the ferric condition. The aerial oxygen has time only to oxidize the glaze superficially and this does not interfere with the color of the glaze. But there is time for the oxygen to oxidize the exposed surface of the body. The hot body below the now solid glaze can not be attacked by the oxygen in the air and, so protected, retains its grey color.

So ferruginous were some of these bodies that it was possible to obtain a light green glaze without any addition of iron to the glaze itself, and a colorless glaze could be used to give the effect. The colorless glaze dissolved sufficient of the ferruginous body to furnish the necessary coloring material from the iron that had been extracted. At the exposed por-

tions, where there was no glaze contact, this extraction process did not occur and ample iron remained there to produce the "iron-foot" or the "brown-mouth."

Ferric Oxide

We must next examine the glazes which owe their color to iron in the oxidized condition, i.e. the glazes in which iron is in the form of ferric oxide (Fe_2O_3). The story is a more complicated one and the range of colors that can be produced by means of this oxide is more considerable. Ferric oxide combines very differently with constituents of the glaze according to the nature of the latter. Thus, if the proportion of bases is comparatively high and the proportion of acid correspondingly low, ferric oxide goes into solution fairly completely, to an extent which may be called combination, because the ferric oxide acting itself as an acid towards these bases is largely combined with them.

An account of a series of experiments will serve to illustrate what is meant by this statement. The experiments were done with borax beads. A borax bead is made by taking a small loop of platinum wire and filling the loop with powdered borax which in the flame of a bunsen burner readily fuses, so as to form a bead of glass held by the platinum loop which it completely fills.

A glass bead was made in this fashion from potassium borate, represented by the formula $K_2O.B_2O_3$: the alkaline portion is represented

by the potassium oxide (K_2O) and the acid portion by the boric oxide (B_2O_3). If 10 per cent of ferric oxide is added to such a bead, a transparent brownish-yellow glass is produced. In this case the proportion of bases (alkali) is relatively high and the ferric oxide has gone into combination fairly completely.

A second bead was made with a different borate of potassium, represented by the formula $K_2O.2B_2O_3$. In that instance the acid portion (B_2O_3) was increased but the basic portion remained the same: in other words a more acid glaze was made. To that glaze was again added 10 per cent of ferric oxide as before, and a dark brown glass was the result, which was nearly black in appearance in a thickness of about 1/16th of an inch.

The next step in the experiment was to remove all the alkali (K_2O) by using boric oxide (B_2O_3) by itself, and to make a glass bead of that. Again 10 per cent of ferric oxide was added to the glass, and it was found that the ferric oxide did not dissolve at all, but became mechanically dispersed throughout the molten mass at a certain temperature. As a confirmation of the experiment, this last-made bead, with the ferric oxide mechanically dispersed in it, had added to it minute quantities of alkali (K_2O) in the form of potassium carbonate (K_2CO_3), and the effect was watched. This is what happened. The ferric oxide, instead of floating about in fair-sized particles, gradually became more and more finely dispersed through the mass, until it became in a

state of division too fine to be visible to the eye
as separate particles. The color became so
deep as to appear black. More potassium car-
bonate was added, little by little, to make the
bead more alkaline: the color gradually be-
came less dense, passing through a deep brown
until a brownish-yellow color was produced.
The ferric oxide had combined with the base
to reproduce the position described above
when the ferric oxide was added to a potassium
borate bead of the formula $K_2O.B_2O_3$. The
process could have been continued until the
brownish-yellow became a still lighter color.
The reader may wonder what all this has to
do with actual glazes, but it is only necessary
to recall the various yellow, brown and black
Chinese glazes to see that this experiment pro-
duced in miniature the colored glazes with
which the collector is familiar. In the T'ang
dynasty highly alkaline glazes were used and
the common colors derived from ferric oxide
varied from a light yellow to a rich brown.
The degree of variation was, no doubt,
achieved by altering the amount of ferric oxide
put into the glazes, which otherwise were
approximately of the same composition. The
alkaline nature of those T'ang glazes encour-
aged the solution of the ferric oxide to bring
about the lighter colors.

The Sung felspathic glazes present a differ-
ent proposition. In these glazes the acidic ele-
ments are much higher in proportion, and the
ferric oxide in consequence does not go so
readily into combination with the glaze con-

stituents. As a result deep brown and black glazes are more commonly found. The black temmoku bowls and similar kinds of ware are cases in point. The type of glaze in those wares is similar to that in the celadons, except, of course, that the iron is in the oxidized condition and not in the reduced form to furnish the green iron colors. The greater acidity of the Sung glazes allows less chemical combination of the ferric oxide with the glaze constituents and consequently the oxide is finely dispersed throughout the mass to produce a deep brown or black effect. The ferric oxide in such a glaze exists partly in chemical combination; but, when there is a notable percentage of the oxide present, e.g. 8-12 per cent, a good deal of the ferric oxide is in a state which may be described as solution. By "solution" is meant a condition when the ferric oxide is in so fine a state of division and so completely dispersed throughout the glaze that a homogeneous color is produced to the eye. Even under a microscope the separate particles are not to be observed. Thus far, attempt has been made to describe the underlying principles governing the way in which ferric oxide can cause coloration of glazes, and explanation has been given of how the nature of the glaze and the variations of its acidity and basicity will cause wide differences in the color produced. The amount of ferric oxide present will also materially affect the final color. In all cases so far described the ultimate result is a color which is homogeneous; and the glaze,

though colored, is transparent in sufficiently thin section.

Saturated Solutions of Ferric Oxide

We must next consider glazes in which the ferric oxide is neither in chemical combination nor in solution as defined above. To enable the reader to understand what must now be described, it is necessary to remember that many substances are more soluble in hot solvents than in cold ones. Thus, if you were to place in a beaker of water some pieces of common salt, the latter would readily dissolve; but after frequent additions, a point would be reached when the cold water ceased to dissolve any more. If, however, the beaker of water were heated, the undissolved salt would disappear and also go into solution. The process could be continued until even the hot water ceased to absorb any more, and what is called a saturated solution at that temperature would be formed. If this hot saturated solution were allowed to cool, some of the salt would come out of the solution and be deposited as crystals in the bottom of the beaker. The hot liquid glass or glaze corresponds to the water and the ferric oxide is the counterpart of the salt. It would be possible to add more and more ferric oxide to a glaze and to reach a point when the oxide would be absorbed while the glaze was hot and molten, but would come out of solution when the glaze cooled. On this fact depend many of the glaze effects furnished by ferric oxide, especially in that group of early wares included in the temmoku family.

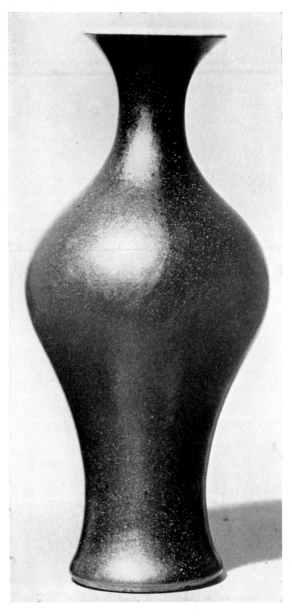

Plate II. Vase with a glaze of ferric oxide which has come out in crystalline form.

There is a considerable variety of different glaze effects in the temmoku wares; and the differences are to be accounted for in largest part by variations of these saturated solutions of ferric oxide in a glass. According to the rate of the lowering of temperature and the passage from a relatively fluid glaze through a treacly one to the solid condition, and to the extent to which excess of ferric oxide is present in the glaze, the oxide will come out in different forms. It may appear as a cloudy mass of minute microscopic particles or as definite crystals, as in the case of the aventurine glazes. These crystals may assume either the well-known appearance of highly reflecting plates of crystalline ferric oxide like specular iron ore, or take the form of a variety of modifications of the same crystalline structure, e.g. needles, feathery or tree-like formations, or more massive shapes. These crystalline forms would present to the unaided eye a black appearance, but with suitable illumination under the microscope would stand revealed as undoubted ferric-oxide crystals with their brilliant and typical red color. On Plate II is shown a vase which illustrates the fact: in general appearance it is black with a black-leaded grate effect. The color is due to ferric oxide, which has come out in crystalline form. The semi-shiny appearance is due to light being reflected from the surface of the crystals. But if such a vase were examined under a microscope with suitable illumination, a glorious mass of deep red ferric-oxide crystals

would be seen. Even with a hand lens and in a strong light, with the white porcelain below to help throw up the light, the red color where the glaze is thin near the foot-rim would be apparent.

If the cooling conditions are not appropriate, the excess of ferric oxide may separate out in a different way or it may not have time to separate. If the cooling process is hurried, instead of producing crystals the oxide may come out as an amorphous scum and produce a muddy appearance.

There is another chemical consideration which it is necessary to outline prior to going into the practical results of this theoretical account of the behavior of a saturated solution of ferric oxide. As already explained, the proportion of base to acid in a glaze is a factor governing the solubility of ferric oxide, and it will be remembered that the more basic or alkaline be the glaze, the greater is the ease with which it will absorb and retain ferric oxide in solution. In a particular glaze, the proportion of base to acid may be just sufficient to keep the ferric oxide in solution throughout the mass, provided no loss of base or alkali occurs. But if the glaze is heated strongly, some of the alkali may be volatilized under the high temperature of the furnace and so be lost. Immediately the proportion of base to acid would be altered and the glaze would become more acid and therefore less able to hold so much of the ferric oxide in solution. It has to come out, and it will separate out in

a state of division so fine as to give scattering of light with a fawn or darker brown appearance.

This loss of alkali through the heat of the furnace is important, and will occur more readily on the mouth-rim of a bowl than on the sides. Recollection of the usual appearance of a temmoku bowl will remind the reader of how the mouth-rim is often different in color from the sides and how the inside is different from the exterior. This point will be referred to again later; at the moment it is only necessary to establish that loss of alkali is a factor governing the ultimate appearance of the glaze. It must also be stated that ferric oxide partially dissociates at high temperatures, with the consequent formation of ferrous oxide plus ferric oxide ($FeO+Fe_2O_3$), to produce what has been described as ferrosic oxide (Fe_3O_4). It is necessary to bear this in mind in considering the chemistry of these highly ferruginous glazes. How far does this dissociation play any part in the effects created? Is the partial conversion of the ferric oxide to ferrous oxide responsible for anything? Such a conversion might be brought about either by the presence of reducing gases in the furnace, or by the dissociation of the ferric oxide by heat. It is perhaps more an academic question than anything else whether the olive tint of the Northern Chinese celadons is due to the formation of a definite ferrosic oxide condition by dissociation of the ferric oxide at a high temperature in a highly acid glaze, or

whether that olive tint is due mainly to a
partial reduction of the ferric oxide in these
thinly applied Northern celadon glazes,
owing to the reducing atmosphere of the
kiln. It really does not matter much: either the
olive tint is due to ferrous oxide and ferric
oxide being arm in arm or else in closer
embrace.

Before describing the practical effect of all
this chemistry in terms of the Chinese wares
which owe their colors to ferric oxide, it is
necessary to remark that any changes of tem-
perature in a kiln during a firing will have
a considerable effect upon the results. One of
the troubles of the modern potter is caused by
what is known as the "feathering" of glazes:
where an even-colored glaze becomes dis-
figured by passages of interruption of the gen-
eral color effect. That great potter, Bernard
Moore, used this trouble in order to make his
well-known crystalline glazes, and something
of the same kind was done by the Chinese
potter. The feathering of a glaze, due to
changes in temperature in a kiln, can best be
explained by analogy. The panes of a window
may show a deposit of moisture, if the atmos-
phere is suitable and the contrasts in tempera-
ture inside and outside a room are sufficiently
marked. The fogging of the glass may, in
frosty weather, produce a definite ice deposit
on the exterior surface. In the same way, if a
glaze is subjected to variations of temperature
and the pot on which the glaze is placed is in
a sufficiently large saggar to allow changes

of temperature to operate, this feathering or crystalline appearance of the glaze is brought about.

If a considerable number of pots are arranged in the saggar and the surrounding atmosphere is relatively small in amount, they will keep each other warm. The heat from the pots placed close together will prevent the atmosphere changing to a sufficient degree to cause feathering in exactly the same way as the frosting of the window could be prevented by circulation of hot air against it. Temperature control in a kiln is a difficult matter and on it depends much of the ultimate effect. The clever potters used a technical defect to produce a highly pleasing result.

Pre-Sung Glazes

It will be convenient at this stage to note the chief glaze effects achieved during the period prior to the Sung dynasty, i.e. during the Han and T'ang dynasties.

A considerable number of the T'ang glaze effects were derived from ferric oxide. The yellows, browns and blacks are so derived. The green so commonly found on T'ang wares is, however, due not to iron but copper, for it would not be possible to produce at one and the same time a ferric or oxidizing effect and a ferrous or reducing effect. The "egg and spinach" glazes, as they are sometimes called, are due to the use of the two metals, iron and copper, under oxidizing conditions at some stage of the firing.

The Han green glazes are more of a problem
and a sufficient number of authentic fragments
have not been available for a proper analysis
to be made of them.* The relatively new tech-
nique of microchemical analysis has not been
applied by which examination could be made
without serious damage to a specimen. It is
dangerous to make statements based solely on
appearance without skilled and experienced
analytical support as some oriental ceramists
are inclined to do. It is probably true to say
that some of the Han green glaze effects are
due to copper but it is also probably true that
some are due to ferrous iron. They vary not
inconsiderably in tone.

There is one feature about the Han green
glazes which is marked. They are unstable
glazes which undergo disintegration under
burial conditions. The silvery effect, due to
iridescence, of the buried Han vessels is a
marked feature of them. The basic nature of
the glaze and the high alkali content whether
the color be due to iron or copper would
account for its instability under severe condi-
tions of exposure. It should be added that we
are here discussing the pre-Sung glazes of a
lead-silicate nature and not the high fired fel-
spathic glazes on a body of a very porcel-
lainous nature which were also produced dur-
ing the T'ang dynasty as evidenced by the
Samarra fragments.

*In Prof. Seligman's paper on Early Pottery from Southern
China (O. C. S. Trans. 1934-35) an analysis by Dr. P. D. Ritchie
of a green Han saucer is included. It shows a considerable iron
content and a mere trace of copper.

There are many specimens of T'ang date with a crude cobalt glaze splashed with yellow or brown ferric oxide, while specimens are also known in which a manganiferous ore has been used to produce a crude purplish color.

The Temmoku Glaze Effects

We must go back to ferric oxide and the range of glazes made from it by some of the Sung potters, to that large family which is often dubbed temmoku. The Tz'ŭ Chou wares also exhibit a number of examples of this type of glaze. The Sung master-potters were adepts at the ferric-oxide game and we must examine their cleverness with care. In the first place, these potters used a different kind of glaze from their predecessors—what has previously been described as a felspathic glaze in place of a lead-silicate glaze.

These glazes required a much higher temperature and were much more viscous in nature. Being so, they had to be applied, as a rule, in a much thicker layer. They flowed sluggishly down the vessel and the thick rolls of glaze which terminate just short of the foot-rim indicate that this was the case. The temmoku ware was largely produced at Chien-yang in the province of Fukien: for that reason it is often termed Chien yao; but a similar ware was made elsewhere in China, especially in the province of Honan.

The type of glaze is similar in both cases, though the color effect varies in certain respects. The glaze used was a felspathic one

with all the general characteristics of its type, high viscosity, considerable acidity and great thickness as a rule.

The most usual form of temmoku bowl consists of a stoneware body with much iron in it. A specimen is shown on Plate III. The glaze is black in color with a bluish tone, which is an optical effect. The black is a deep brown-black. In the so-called hare's fur bowls the black is streaked with lightish brown markings; in the specimen illustrated, the brown is more widespread than is often the case. At the mouth-rim of these hare's fur bowls, the glaze is thin and appears as a dry-looking reddish-brown surface which is rough to the touch and is often hidden by a metal rim. Close examination of such a bowl under the microscope shows that the main part of the glaze consists of a blackish-brown glass. On the surface, and penetrating slightly below the surface at the hare's fur markings, would be seen opaque brown particles, or finely divided but closely aggregated tiny spheres. Where the particles are smallest and sparsely distributed, the light scattered from them would be seen to have a bluish tinge. At the mouth-rim, the dry-looking rough surface would give no appearance of brown particles, but appear as a network of interlacing crystals. Other types of ware belonging to the same family, with the same kind of brown markings on a black underdepth, would present the same appearance under a microscope. All are due to the separation out on cooling of ferric oxide from

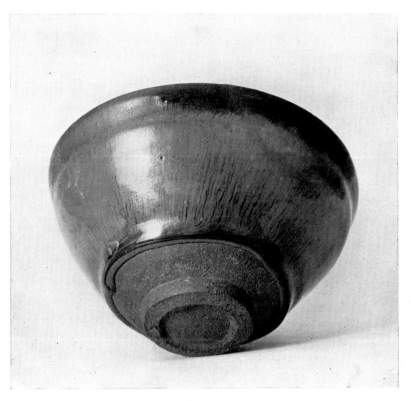

Plate III. Temmoku bowl with hare's fur markings.

a glaze containing more than it can hold when in the cold, solid state. The oxide is present in too high a concentration to remain entirely in solution, or in that state of very fine division in which it exists in the clear black glass seen in other portions of the surface-glaze and throughout the depth of it. The extent to which the surface is coated with the brown excess of ferric oxide depends in the main on the amount of the oxide originally put in.

So much for the explanation of the usual type of hare's fur bowl, except to recall the fact, already mentioned, that owing to the loss of alkali in the heat of the furnace, which occurs on the exterior more readily than on the inside, the brownness of the surface is more marked on the outside of the bowl than on the interior.

Figured Temmoku Bowls

Some account must next be given of the sub-group of the ware known as the figured tem-mokus: in these bowls the glaze is decorated with floral designs, geometric patterns or representations of birds and insects, in a black glaze showing up in contrast on a lighter glaze surround. Sometimes the figuring is portrayed in lighter color on a dark background. In all cases, the design and groundwork glaze are produced at the same firing; and it is no case of an enamel glaze being applied on top of a previously applied and higher-fired glaze. The Chinese potter achieved the results from his knowledge of the behavior of ferric oxide in different concentrations in a glaze of vary-

ing compositions. What he did, no doubt, was this. He coated his bowl with a glaze mixture which he knew would produce a brown on firing; he then removed the glaze by means of a pointed and bevelled stick to make the design he wished to see displayed. As a result he would have the design in the form of vacant spaces. In this vacant area he next applied another glaze mixture containing the right amount of ferric oxide to give a black color on firing. In the furnace the two glazes welded together at the outlines of the design and the latter appeared in black, contrasting with the brown surround. The potter may have—sometimes at all events—varied his technique by applying the second, different ferric-oxide, glaze on the top of the initial one, without removing the latter first. He would have got a similar kind of effect, but the sharpness of the design would not be so clear. It will be remembered that in some of the figured temmokus the design is rather fuzzy and blurred: that is due probably to the potter having worked with this other technique. In Sir Herbert Jackson's work with which the author was privileged to be associated, this question was explored at some length, not only by microscopical analysis but by synthetic experiments. Temmoku glazes were made precisely in the way described; and on Plate IV are shown certain trial cups fired at that time. No attempt at drawing was made and either patches of contrasting color were added to the cups or initials were inscribed in a glaze of one color

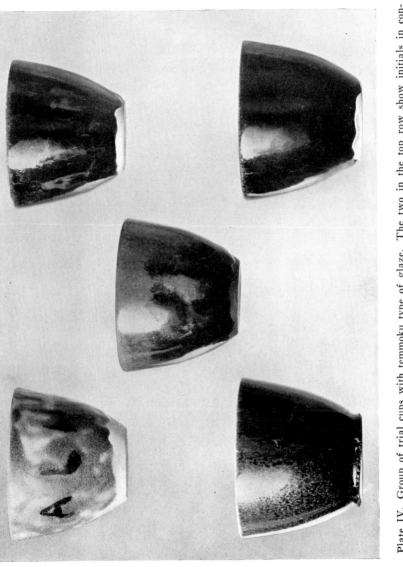

Plate IV. Group of trial cups with temmoku type of glaze. The two in the top row show initials in contrasting glaze. The cup in the center shows contrasting passages of glaze. The left-hand bottom cup shows a ferrosic-oxide glaze and the right-hand bottom cup a dense black ferric-oxide glaze.

on a groundwork of a different color. Initials in black on brown, or in brown on black, were written in glaze.

The blotchy appearance of some of the temmoku glazes is probably also accounted for in part in the following way. When bubbles of gas contained in the glaze are driven to the surface on heating a viscous glaze containing a substance like ferric oxide, they will carry with them upwards a certain amount of the ferric oxide and other glaze ingredients. If these bubbles come to the surface in a mass and burst, a grey scum may be formed and the blotchy appearance could be accounted for in this way. Further, as already mentioned, if the cooling process is hurried, the separation out of the ferric oxide takes the form of a scum and produces a muddy appearance. The tortoiseshell effect, which is not infrequently found in the figured temmokus, may have been brought about by adding spots of clay to the glaze mixture.

"Oil Spot" Glaze

This bubble-bursting process is likely to account for the much prized "oil spot" glaze. The actual "oil spots" are caused by light being reflected from the flat surfaces of the ferric-oxide crystals formed at the spots. The vase shown on Plate II with a black-leaded grate effect owes its semi-shiny surface to light being reflected from such crystals. The vase might be described as one huge "oil spot." The sporadic nature of the "oil spots" on these bowls could be accounted for by bubbles burst-

ing. An analogy may help to explain what is meant. When soap suds in a basin of water subside, i.e. burst, to leave an even and flat surface to the water, the latter is seen to be covered with a filmy deposit showing rings, marking the circumferences of the bubbles where they rested on the surface. Much the same kind of action would take place in the event of bubbles of gas bursting on the surface of a glaze of the type in question.

The "spotting" of a glaze is a troublesome feature in modern production and Dr. Mellor has discussed it in terms of present-day practice.* He has explained how when there are particles in a fluid glaze, these particles may flow at a different rate from the matrix in which they are placed: a process of liquation or apparent separation of the constituents takes place, or may occur. If a bubble bursts and a pit is formed in consequence, because the glaze surface has not time to recover its smooth even surface, the more fluid part of the glaze may be drawn by this process of liquation into the pit before the less soluble portions (the particles) can get there, and spottiness may result. Plate V depicts what has happened in certain cases on a modern glazed surface. The possibility of this kind of process helping to produce the "oil spot" effect by the aggregation of the ferric-oxide crystals in a sporadic fashion should be taken into account.

The two bowls depicted on Plate VI are

* "Spitting of Glazes, Part II." *Trans. Ceramic Society,* Vol. xxxv, 1936.

Glaze

Body

Glaze colored by an insoluble stain
(diagrammatic).

Pale spots on pink glaze (\times 1 diam.).

Elongated pale spots on brown
glaze (\times 1 diam.).

The separation of "manganese"
from solution (\times 1 diam.).

Blue spots on celeste-blue glaze
(\times 1 diam.).

Plate V. Modern glazes, showing result of liquidation of a glaze.

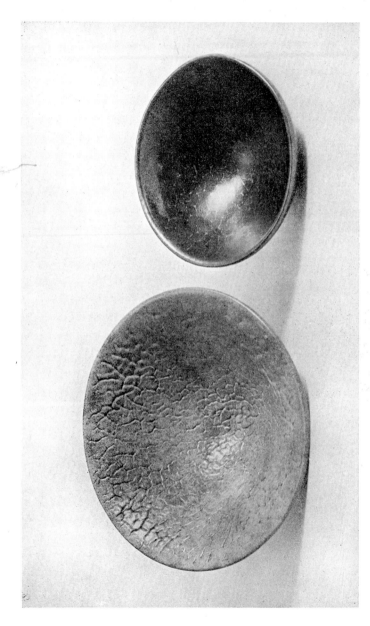

Plate VI. Two Sung temmoku bowls. Fig. 1 in original condition with "lizard skin" glaze; fig. 2, bowl with similar glaze, refired.

interesting from several points of view. Both started their life in London with the same appearance, although their sizes and shapes were somewhat different. Both are temmoku bowls of Sung date which had the well-known grey lizard-skin glaze. The bowl in fig. 1 is exactly as it came from China, having been made there about 900 years ago. The bowl in fig. 2 was refired at a temperature of about 1300° C. a few years ago to complete the process which had been suspended for a considerable number of centuries. The grey lizard-skin effect, with the cracks and fissures in the glaze which give it the name in conjunction with the color, is brought about by incomplete firing of the bowl. The thick glaze, put on in the suspended condition, cracked as it dried and the temperature applied was not sufficient to fuse completely the glaze mixture, nor to allow the ferric oxide to become diffused properly through it.

The glaze on the second bowl, fig. 2, on refiring fused completely; the cracks healed up and the color turned a deep black, but at the places where the fissures welded, the ferric oxide came out as an "oil spot" effect, in the form of stars or lines conforming with the fissure junctures. As a result an uncommon type of "oil spot" bowl was produced. At the mouth-rim of the bowl, the ferric-oxide crystals are more uniform in their arrangement, and the effect on the mouth-rim is precisely the same as that which appears all over the vase shown on Plate II.

Other Forms of Ferric-Oxide Glazes

There are a number of other glaze effects due to the behavior of ferric oxide in a glaze. There is what is known as the "iron rust" glaze which is common in eighteenth-century porcelains and which is also found on Sung wares; a reddish-brown glaze with dark spots or patches in it of a metallic appearance. The reddish-brown part of the glaze can readily be interpreted from what has been said already. The dark spots consist of large and dense ferric-oxide crystals.

The mirror-black glaze of the eighteenth century was not a black ferric-oxide glaze, pure and simple, such as those described in connection with the temmoku wares. The Chinese potters added a cobaltiferous ore of manganese and by that means obtained a much blacker black—"as black as your hat"—in contradistinction to what has been described as a deep brown-black.

A very dense black glaze can be obtained by using manganese and cobalt, and such a combination is used today for making jet-black glazed tiles.

The somewhat rare black Ting yao was obviously made from ferric oxide and is analogous to the temmoku black glazes. Sir Percival David in a paper read before the Oriental Ceramic Society has thrown considerable doubt upon the veracity of the Hsiang Album record and consequently upon the reference therein to the purple Ting yao. It is therefore unnecessary to attempt to provide

any scientific explanation of such a color in a
glaze of Sung type.* Some reference to man-
ganese will be found in a later chapter.

The yellow T'ang glazes have already been
dealt with, and explanation has been furnished
of the way ferric oxide in a suitable and suffi-
ciently alkaline glaze will go into solution
more and more completely to impart a lighter
color to the glaze, until a yellow color is pro-
duced. The range of Ming yellow glazes is
due to this fact, and there is no evidence that
any metal other than iron is necessary to pro-
duce them. The suggestion has been advanced
that other metals were employed and antimony
has been cited. It is, of course, true that various
yellow glazes can be made from other metals.
Cadmium and antimony will produce yellow
glasses, so will uranium (a fine orange-yel-
low), and so will silver for that matter. But
there is no authoritative evidence that the
Chinese used these metals for that purpose.
The difference in tone of the Chinese yellow
glazes and the differences in the several Ming
yellows are marked, but can be accounted
for by the reactions described. Some of the
later Chinese yellows have not been critically
examined.

Ferric-Oxide On-Glaze Effects

There are finally the ferric-oxide on-glaze
effects of which the coral-red of the eight-

* An attempt to do so, prior to Sir Percival David's paper,
will be found in the *Oriental Ceramic Society Transactions,*
1928-30.

eenth century is a familiar example. The color of ferric oxide by itself is determined in large part by the time and temperature of the roasting of the ferrous salt from which it is obtained. The color is also dependent upon the size of the grain particles of the ferric oxide. Thus, colors varying from yellow through reds and browns to black can be obtained. The paints known as yellow ochre, burnt ochre, burnt sienna and burnt umber are all derived from ferric oxide. The potter obtains a number of color effects by the use of these different colored ferric-oxide preparations, which are added to a suitable glaze mixture in which they become incorporated and impart their color to it.

These glazes are low-fired, as are the enamel glazes, and the low-firing temperature is continued a sufficiently short space of time to prevent the ferric-oxide particles becoming dissolved in the glaze, and only to be incorporated in it. If the firing operation were to be continued longer, or if the temperature were higher, the particles of incorporated ferric oxide would become more and more completely dissolved in the glaze and produce a clear yellow glaze of the type already discussed. In some specimens it is found that the red surface-glaze shows scratches which expose the white underglaze. This iron-red, or rouge-de-fer glaze as it is termed, was commonly employed in the Ming wares; while the coral-red of the Manchu era was one of that dynasty's many achievements. So much for the

iron story. Many subsidiary points have been omitted in an account which must necessarily be incomplete. There are several questions in connection with the behavior of ferric and ferrous oxides in a glass or glaze under different conditions which have not been fully elucidated and remain to be cleared up by further research work.

Summary of Ferric-Oxide Effects

Ferric oxide is taken up by molten glaze in different ways and to different extents, according to the nature of the glaze—especially according to its acidity or its alkalinity. The more acid the glaze is, the less will it take up: the more alkaline it is, the more will the ferric oxide combine with it. When the combination is the more complete, the lighter will be the ultimate color. The color is also affected by the amount of ferric oxide present and available for solution.

The splashed effects on the temmoku wares and the "oil spot" glaze are due to excess of the oxide coming out in different forms on the surface during the cooling of the saturated solution.

The controlled effect, achieved in the figured temmokus, is brought about by using glazes with different concentrations of ferric oxide in the contrasting portions.

The rouge-de-fer glaze and its close relatives are on-glaze effects produced under mild firing conditions which do not allow the oxide to be dissolved in the glaze but only to be firmly incorporated in its surface.

THE COPPER STORY

*I*T IS NOW

necessary to examine the effect of another very important metal used by the Chinese potter—copper. We have seen that iron can produce a very fair range of colors, but copper does still better. The copper story is different from the iron story in one main respect. In the case of iron, the two oxides, ferrous oxide and ferric oxide, were responsible; but while the two oxides of copper, cuprous oxide and cupric oxide, have their effect, the metal itself also plays an important role. In fact, for the ultimate color effects it may be said that cupric oxide and copper in an elementary condition play the leading parts.

Effects From Cupric Oxide

The effects produced by cupric oxide, which is represented by the formula CuO, must first be considered. Cupric oxide gives rise to a variety of colors ranging from blue to green; and that color series is accounted for by the varying amounts of cupric oxide present and the nature of the glaze in which it is placed. In general, it may be stated that the more basic or alkaline be the glaze, the greater will be the tendency to produce the blue color; and the more acid the glaze, the greater will be the

predominance of the green. That copper produces both blue and green colors will be a familiar fact by recalling the appearance of blue vitriol or copper sulphate, and of a Chinese bronze which has a deposit of verdigris upon it.

Cupric oxide in the mass and by itself is black, though in a very finely divided state it is brown. When, however, it is dissolved in a glass or glaze, it colors it blue or green, depending in large part on the amount and nature of the alkaline constituent in the glaze. We will first consider the greens that can be produced by cupric oxide. A considerable range of this color can be obtained, and the reader will be familiar with the row of them catalogued by the Manchu potter: cucumber-green, apple-green, grass-green, and so forth. All these colors are due to cupric oxide and are not difficult to produce by varying the amounts of the oxide and the alkaline and the acidic constituents of the glaze. The T'ang green has already been mentioned and it is not dissimilar in tone from some of the Manchu greens.

Green glazes from cupric oxide are all relatively easy to bring about; but to obtain, and retain, a blue from cupric oxide is more difficult, and something must be said of how blue copper glazes are made, of which the turquoise is perhaps the most beautiful and striking.

Cupric oxide dissolves in a glass or glaze formed of potassium silicate or of sodium sili-

cate, or a mixture of the two, to give a blue color at a temperature of 1300° C. If alumina is present as well, there is more than a tendency for the blue to turn into green. If again the alkali present, instead of being potassium oxide or sodium oxide, consists of lime or magnesia, the tint passes into green instead of blue.

If lead is present, the potash-lead-silicate glaze is blue, but again the tint tends to green if the lead is in excess. If to such a glaze alumina be added, the glaze becomes a brilliant green. What do these crude statements of fact imply? They mean in general that the blue glaze is a delicate one which will turn green on the slightest provocation; and the reader will recall how often a turquoise glaze shows a tendency to merge into green, and how, in poor specimens of turquoise, the whole effect is a rather dirty blue-green. Some of the finest turquoise glazes have just a suspicion of green which adds to, rather than detracts from, the color effect. It softens the garishness of the staring blue. It will be realized from what has been said previously that, if the temperature is raised, there is a tendency for the alkali to volatilize and so be lost. As the alkali helps to stabilize the blue color, the loss of any of it tends to make the glaze turn green. Hence an increase in temperature is likely to disturb the relative amount of alkali present and make the glaze verge to green. All these factors operate to make the retention of a good turquoise color difficult, and they

account for the fact that this glaze is some-
what uncommon to find in perfect condition
of color.

It would be necessary to go into consider-
able detail in order to give a complete account
of the behavior of cupric oxide in glazes of
different compositions;* and in addition to
what is stated above it is only necessary per-
haps to make two further observations. A
potter is forced to keep the alkali in his blue
glazes below a certain limit, for, if he does
not do so, the whole glaze would be apt to
break down on exposure in a humid atmos-
phere, owing to the attack on the alkali. The
deterioration of turquoise glazes will be
familiar, and cases will be recalled where a
coating of iridescence is found on the blue
glaze.

The other additional point which is worth
recording is the fact that the glaze will dis-
solve material from the body on which it is
placed; and these body extracts may turn the
blue glaze into a greenish one. The well-
known Persian blue glaze is generally well
preserved and of a particularly good color,
and that fact is accounted for in large part by
the siliceous nature of the body used, for, as
noted above, the presence of silica in the
appropriate silicate helps the retention of the
blue.

* Dr. H. Hecht went into the question of cupric-oxide glazes
very fully from this point of view many years ago, *Tonind.
Ztg.* XIX, 453, 1895.

The Reduced Copper Glaze

The other forms in which copper may appear in ceramic glazes are cuprous oxide (Cu_2O) and the metal itself. Cuprous oxide does not appear to be a substance which is by any means common in Chinese glazes. Of the considerable number of specimens of reduced copper glazes (whole colors) which Sir Herbert Jackson examined, in only one case was it certain that copper was present as cuprous oxide and that only in a very small amount, most of it being copper in the elementary condition. On the other hand, certain enamel colors were not examined from this point of view and some of the red decorative elements on the Manchu porcelains may be derived from cuprous oxide.

Cuprous oxide is an orange-yellow in a fine state of division, assuming a magnificent red color in larger aggregations of crystals. The brilliant red Egyptian glass of the eighteenth dynasty owes its color to cuprous oxide. If such a glass is examined in section it would be seen that on the surface which has been exposed to the air at the time of melting, the glass was green, due to cupric oxide. Below that layer would be found a fine orange stratum which slightly penetrated into a bed of brilliant red. The orange-yellow would be cuprous oxide in a finely divided state and the brilliant red would consist of larger aggregations of cuprous-oxide crystals.

We find very small evidence of the persistence of cuprous oxide in Chinese glazes, and the red glazes derived from copper are due to

more complete reduction of the cupric oxide, down to the metal itself. All the oxygen is taken away and the metal is left in an extremely fine state of division in the colloidal form.

Colloidal Copper

A colloid is the opposite of a crystalloid and in contrast to the latter will not pass through a membrane; it is a jelly-like substance. The term colloid (or colloidal particles) has also been extended to denote minute and ultra-microscopic particles.

The fine state of division in which the colloidal copper is separated is somewhat difficult to realize. It has been estimated that the diameter of one of these particles of colloidal copper is about 10 microns. A micron (or μ (*mu*) as it is generally called) is $\frac{4}{100,000}$ ths of an inch. About 500 of them could sit on the head of a small pin with plenty of elbow room. A human red blood-corpuscle is 7.5μ.

Another general point that should be mentioned before describing what probably happens in the production of a reduced copper glaze is that a very small amount of copper must be present in order to produce the best red color, not more than about one-half per cent.

The following episode is an interesting illustration of how a minute quantity of copper will produce a red color in a glaze. A potter who happened to be using wood ash for some of his glaze effects—it will be remembered incidentally that the Chinese potters used ashes from bracken fern in a similar way as a source

inter alia of suitable alkali—included by accident a copper coin in the shavings from which the ashes were subsequently obtained. The coin was not observed until the shavings were burnt, when it was removed none the worse for its ordeal. All the pots which were subsequently glazed from the mixture in which the ashes were incorporated were colored red, instead of being white as intended. The minute amount of copper which had become part of the ashes was sufficient to color the glaze red.

Sang-De-Bœuf Glazes

We must now examine the way in which the fine red from copper is produced in a glaze and the principles on which the famous *lang yao* and other copper-red glazes were brought about. It is a difficult story to tell, or at all events to convey in simple language. A comprehensive account will be found in a paper by Dr. Mellor.* This paper is the most complete statement to date and adds considerations which have not been recorded in other presentations of the subject. The following are the leading features which are to be noted.

The copper-red glazes owe their color to cupric oxide which has been reduced to copper itself in a finely divided and colloidal state. The red color is due to the even aggregation of these finely divided particles to form a band in a certain portion of the layer of glaze. The formation and maintenance of this red band are assisted by the presence of tin or iron oxide

*The Chemistry of the Chinese Copper-red Glazes, Part I."
Trans. Ceramic Society, Vol. xxxv.

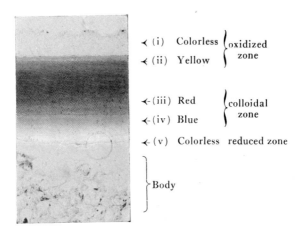

◄ (i) Colorless ⎰oxidized
◄ (ii) Yellow ⎱ zone

◄-(iii) Red ⎰colloidal
◄-(iv) Blue ⎱ zone

◄-(v) Colorless reduced zone

⎱Body

Section through a reduced copper-red in-glaze (× 100 diam.).

Plate VII. Section of reduced copper-red glaze.

in the glaze. The copper-red glaze is brought about by a reducing atmosphere at the outset and it is finished off in an oxidizing atmosphere. On Plate VII will be seen a colored microphotograph of a section of a copper-red glaze which has been magnified 100 diameters. There are five layers. The first, starting from the surface of the glaze, is colorless or slightly greenish in tint. The second consists of a narrow band of yellow, and this is sometimes absent; the third is a relatively broad band of red which is followed by a narrow band of blue; while finally there is a colorless or greyish layer next to the body.

It must be stated that when colloidal copper is in an extremely fine state of division it looks yellow; in a slightly less fine state it is red; and when the particles are larger still (but of course still extremely small) it looks blue by transmitted light. At the outset when the glaze is subjected to a strong reducing atmosphere, the cupric oxide (the original coloring matter, in a concentration of not more than one-half per cent), together with any iron oxide (or tin oxide) that may be present, are all reduced. The cupric oxide is reduced to cuprous oxide or to copper itself and the iron oxide is reduced to ferrous oxide. Any tin oxide, if present, would be reduced from stannic oxide to stannous oxide.

The reduced copper would be dissolved in the glaze, which would be colorless at the outset; and that is the position shown by the fifth layer in the microphotograph next to the

body. The ferrous oxide present would help to complete the reducing action of the atmosphere. That is the initial stage. In comes the oxidizing atmosphere and the aerial oxygen begins its onslaught. It first attacks the surface of the molten glaze and, being full of vigor, finds little difficulty in oxidizing the first layer of the glaze, turning the copper in it into cupric oxide—hence the first layer of very slightly green glass, owing any color it has to cupric oxide. The aerial oxygen has spent itself to some extent and with diminished vigor goes deeper; it attacks the reduced copper lower down and any ferrous oxide that may be present, turning the latter into ferric oxide. It has not the strength now to convert the reduced copper into cupric oxide but it can smash it up very finely—so fine that it is divided into the size of particles which give a yellow color by transmitted light—the second layer in the photograph. On it goes, still losing strength, and now it can only break up the copper into less fine particles to produce the size required to give the red color. This stage is represented by the third layer, the red band. It is nearly spent, despite the addition of further supplies of aerial oxygen which work their way in; but as a final effort it gets down a little farther and divides up the colloidal copper into less minute particles to give the blue layer. There it is finished, and it has no strength left to do anything with the final layer next to the body itself. The iron oxide helps the business not inconsiderably—any tin which may be present

would have the same effect. The ferrous oxide, turned into ferric oxide, helps to stabilize the colloidal copper and to keep it dispersed, in order to form and maintain the red band of colloidal copper. The Chinese evidently knew the importance of the presence of a certain amount of iron oxide, for we read in the literature of their dressing the body with yellow clay —an obvious source of iron oxide.

Such in brief outline is the most recent explanation of how a copper-red glaze comes about from a chemical point of view. The new and interesting point is the suggestion that aerial oxygen plays an all-important part. The copper-red glazes have been looked upon as the result of a reducing atmosphere only.[*] Now that Dr. Mellor has established the role played by aerial oxygen as a finish to the reducing action, many of the variations of reduced copper glazes become more intelligible. Details have been omitted to simplify the conception.

There are, however, a few additional facts which are of interest, especially as they serve to explain some of the effects which are familiar. If a reduced copper glaze is rapidly

[*] I am ignoring the statement which has been made that whiffs of oxygen (or air) were admitted to the kiln in order to provide blue (cupric oxide) splashes, such as are found in the Chinese flambés. These streaks were caused by different agencies as is explained herein.

Important earlier discussions of the reduced copper Chinese glazes will be found in Prof. Collie's paper in the *Transactions of the Ceramic Society*, Vol. xv; and in the paper on the subject in the *Oriental Ceramic Society's Transactions*, 1921-2, by Sir Herbert Jackson and Prof. Collie. Earlier discussions of the subject are to be found in the *Collected Writings* of Hermann A. Seger.

cooled, the sequence of events described will not have time to occur; the particles of colloidal copper will not disperse to form the red color and the glaze will be colorless or faintly yellow. If such a rapidly cooled glaze be heated up slowly, the particles of colloidal copper will become dispersed in the now fluid glaze in such a manner that the glaze turns red.

Again, if the glaze, of which a microsection is shown on Plate VII, were to be ground away so that all was removed except the final colorless layer next to the body, the remaining glaze would, on heating to fluidity, turn red. If that remaining glaze were thick enough, it would arrange itself in the series of colored layers shown in the illustration. The aerial oxygen would go through the same form of attack as described.

This rapidly cooled colorless glass may be said to be in a state of suspended animation, not altogether unlike the condition of a newly-born baby. Quicken it by heat and a breath of life-giving oxygen, and the particles of colloidal copper come into being and the blood-red color diffuses in the appropriate layer of the glaze.

At the mouth-rim of a sang-de-bœuf vase invariably, and in the upper part of the neck often, the glaze is white and not red: sometimes it may have streaks of red running into the white portion. At such places the glaze is necessarily thin and the aerial oxygen has had a relatively easy task in its attack on the reduced copper. Consequently it has oxidized

the whole glaze and bleached out the red col-
loidal copper and turned it all into cupric
oxide. The color is only very faintly green, be-
cause the amount of copper present must be
very slight in order to produce the most bril-
liant red. If the amount of copper is greater
than about one-half per cent, the red becomes
opaque and dull looking; and when the copper
is well over half of one per cent the color
assumes a red-sealing-wax appearance. This
latter form is frequently found, especially in
some of the Kuang-tung glazes.

It may be of interest to make a remark about
why, in the fine specimens of K'ang Hsi *lang
yao,* the glaze terminates in an even roll at the
foot-rim without over-running the base;
whereas in the Ch'ien Lung specimens the
glaze is generally ground off where it has run
over the base-rim. It is not possible to give a
complete explanation, but it is possible to sug-
gest a way in which over-running might be
prevented. If the body near the foot-rim were
smeared very thinly with powdered charcoal
or finely ground alumina, the glaze, as it
flowed sluggishly down the vase, would be
arrested when it came to the coating and pile
up there, because it could not "wet" the surface
and flow over it. Moreover, glazes high in
alumina, which would be derived from China
clay, flow hardly at all owing to their high
viscosity. A glaze of this type might have been
used for the *lang yao* effect, while, in later
days, glazes with a diminished alumina con-
tent might have been employed. The experi-

ment of producing a controlled foot by smearing a thin film of powdered charcoal on the body near the foot-rim has been made successfully. Why the foot-control was not used in the later part of the eighteenth century it is not possible to say. The details of the technique of the copper-red glazes were jealously guarded, as is known from Pére d'Entrecolles' letters, and it may be that some of the niceties were lost on the decease of the experts who possessed knowledge of them. That is mere conjecture.

One other remark may be made about the appearance of these sang-de-bœuf glazes and their close relatives, the flambés. It will be found that there is considerably less crazing on the red part of the glaze than there is on the colorless portions. In a flambé glaze, the red patches and red streaks are fairly free from crazing, while the passages which are not red will be found to be heavily crazed. This observation is in agreement with the general experience of modern potters on the crazing tendency of copper glazes.

Chün Yao

At this point it will be convenient to deal with the Chün yao, since one of its characteristics, or at all events a feature displayed in many specimens of it, is the occurrence of reddish or reddish-purple splashes set in a surrounding glaze of opalescent blue or blue-grey. These splashes of color are due to reduced copper: the red color is due to copper in the col-

loidal condition already described, and the purplish effect to the mixture of blue and red produced by a combination of color arising from the red and blue colloidal particles in conjunction with a certain amount of opalescence. In some cases these reddish-purple splashes have a slight amount of green on their surface and the cause of this appearance will be understood from the description given on p. 78 of the effect of aerial oxygen on a reduced copper glaze under certain conditions.

The reduction of the copper would obviously be helped by the presence of ferrous iron and the dispersion of the colloid copper would also be assisted, as previously mentioned, by the presence of iron. Moreover, there are certain types of Chün glazes which bring iron into mind. There is what is known in the Chinese literature as "plum colored" Chün, and it is evident that the unripe or green plum is referred to. There are also references to the *ta lü* or deep green Kuan ware. In both cases ferrous iron is suggested and the known specimens of green Chün ware give all the appearance of a ferrous-iron glaze. The similarity between these green Chüns and the Northern Chinese celadons is marked, although the bodies of the two types of ware are different in appearance.

A quantitative analysis was made of a fragment of milky-blue Chün ware from a Honan kiln-site of twelfth-century date (with no red splash in it) ; the analysis, made by Mr. C. D. Littler, was as follows:

$SiO_2 : 67.08$ $MgO : 1.10$ $P_2O_5 : 0.40$

$Al_2O_3 : 13.20$ $K_2O : 4.48$ $TiO_2 : 0.50$

$Fe_2O_3 : 1.62$ $Na_2O : 0.46$ CuO trace

$CaO : 9.34$

The phosphate present is equivalent to 0.68 per cent. $Ca_3 (PO_4)_2$. Fragments from other Honan kiln-sites present similar features though the amount of phosphate in them appears to vary.

While the foregoing analysis is an accurate one of this particular fragment, it must be remembered that specimens from different kilns may well vary. For instance, in a Chün glaze with a reduced copper-red splash, analysis might show the presence of tin and possibly lead. In such a case it would not be rash to surmise that the source of the copper was a bronze alloy, and the presence of tin and lead would be explained by the use of that copper alloy to provide the reduced copper.

The opacity of the glaze may be accounted for by the phosphate present, coupled with a certain amount of clay in it; and the blue tone is due to ferrous iron. Part of this ferrous iron exists as ferrous phosphate which is blue as for example in the mineral vivianite. Many of the Chüns, however, are greyish green in color rather than blue, and the iron present, in the reduced condition will also account for that color.

The above analysis shows that copper is in no way responsible for the blue color. But as statements have been made suggesting that the

blue appearance can be attributed to copper in such a glaze, cf. W. B. Honey, Ceramic Art of China, p. 70, it was thought desirable to fire a series of trial glazes with different copper contents and of varying alkaline and acidic natures. This was done through the kindness of Dr. Marcus Francis, the late Director of the British Pottery Research Association. It was found that unless there was at least one per cent of copper present, no pale blue color was produced. The argument advanced that because a very small amount of copper is sufficient to produce a pronounced red color in the reduced colloidal condition, a similar minute quantity will produce a blue cupric oxide effect is fallacious. The suggestion is the more untenable since these Chün glazes have, as will be seen from the analysis given, a material amount of iron present. Under the oxidizing conditions necessary to produce a blue cupric oxide effect, the iron will be oxidized to give a prominent and over-riding yellow or brown result. Various trial glazes with copper and iron contents of different amounts, and with and without phosphate present, were fired under oxidizing conditions: a yellow, brown or black glaze resulted even when a copper content as high as 5.0% was added.

Several of the kiln-site fragments examined show many pores in the glaze arising from the presence of gas bubbles. These can be accounted for by the thermal decomposition of the calcium phosphate or the ferrous phosphate present. When these salts are subjected

to excessive temperatures, as for instance when the glaze is overfired, the phosphate will decompose with the evolution of phosphorus which in air immediately forms phosphoric oxide (P_2O_5). Each centre of decomposition produces a gas pore in the glaze and gives it a bubbly appearance.

Another interesting fact may be noted which accounts in part for the appearance of some of the scientifically analogous Sung wares, e.g. those of the Kuan type. Some fragments from Hang-chou displayed a typical green-grey glaze with brown craze lines running through it. The glaze derives its color from ferrous iron which owing to the phosphate present exists as ferrous phosphate. If ferrous phosphate is exposed to aerial oxygen it will turn brown even at atmospheric temperatures, owing to its oxidation. The craze lines furnish a means of ingress for the aerial oxygen and at such places the oxygen reacts on the ferrous phosphate. So definite is the craze pattern, that it looks like a stained crackle. But in such specimens artificial staining is not necessary to produce the result. The aerial oxygen does not attack the ferrous phosphate in the uncrazed portion owing to the protection afforded by the surface skin of the glaze. More scientific examination of these early phosphatic glazes might throw additional light on the Kuan and Ko type glazes and their varying degrees of crackle effect. The presence or absence of bubbles in these glazes, on which comment will be found on p. 101, might also be examined

afresh in the light of these preliminary observations on the formation of gas bubbles due to the thermal decomposition of ferrous phosphate.

Reverting to the Chün glazes, collectors will be familiar with the fact that passages, often no larger than spots, of red appear in the milky blue or blue-grey glaze of specimens of Chün ware. In the so-called "soft" Chüns (the term "soft" applies to the body used, not to the glaze) these spots or passages are sometimes prominent and are due to the presence of copper in the reduced condition. Attention has already been drawn to the fact that a very minute quantity of copper is necessary to produce a red color in a glaze under reducing conditions. The same kilns were used doubtless for firing Chün wares with copper splashes and those without them. Particles of copper would be likely to be present in the kiln, on the roof and sides, in infinitesimal quantities but quite sufficient to impart a reddish tinge to a glaze. The more pronounced red fleckings might have been induced by intentional additions of copper to the glaze.

Another point in connection with the Chün glazes calls for comment. A feature mentioned in the Chinese literature describing the Chün ware, and especially the gorgeous bulb-bowls and flower pot holders, is the presence of "earthworm" markings, small rambling lines in the glaze which give rise to this description. These lines mark places where the glaze has fissured during the early stages of the firing

and where those scars have healed during the final stages: the process of liquation described on p. 48 accounts for the contrast in color of the rambling lines with that of the immediately surrounding glaze. The softer matrix of the glaze has flowed into the fissures more rapidly than the glaze with its suspended particles.

Eighteenth-Century Flambés

The blue fleckings which are a familiar feature of the eighteenth-century flambés, owing their red color to reduced copper, can be accounted for in a different way from the opalescent blue of the Chün wares. In the next chapter the subject of opalescence is dealt with in a general way, but its bearing on the flambé wares may be mentioned here. The opalescence in this case is due to the separation out of some mild opacifying agent and/or to the incipient devitrification of the glaze. The glaze may undergo a change in its structure so that minute crystals are formed in it. Instead of the glass remaining perfectly "glassy" and vitrified, it may become slightly devitrified by the formation of minute crystals. These crystals would reflect light of a pearly-white or bluish-white nature and give a bluish appearance in the portions which have undergone such a change. On Plate VIII a microphotograph of a section of a Chinese flambé glaze of the eighteenth century is shown and the tiny crystals, very much magnified, will be seen. It does not seem at all necessary to assume the presence of some special opacifying agency, such as a phosphate, for explaining these fleck-

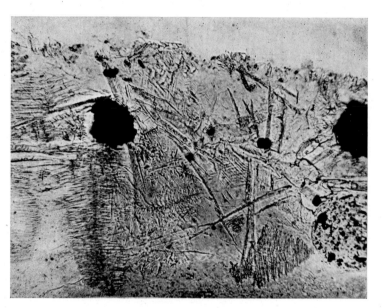

Plate VIII. Section of flambé glaze showing tiny crystals.

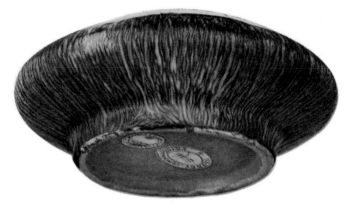

Plate IX. Brush bowl with flambé glaze, Ch'ien Lung period.

ings. The process of devitrification causing opalescence is specially liable to occur where there is shortage of alumina in the glaze. If tin were present (though there is little evidence of the practised use of tin by the Chinese potters), the tin oxide would be very inclined to separate out from the cooling glaze to form opalescent patches or streaks. The combination of these bluish opalescent streaks with the underlying red of the reduced copper would furnish the purplish effects which are familiar in the flambé wares. A typical specimen of a flambé brush pot of the Ch'ien Lung period is shown on Plate IX.

Reduced Copper As An On-Glaze Effect

Something must next be said about a different form of copper-red glaze which, instead of being an in-glaze effect such as that described above, is an on-glaze effect. It is doubtful whether the Chinese employed the technique now to be described, though it is well known in certain Hispano-Moresque red lustres and certain early red Persian glazes. The on-glaze red coloration is also due to colloidal copper, though the particles of colloidal copper are not produced by separation from a solution in the glaze, but as a condensation from a vapor of copper on its surface. If a basin of copper chloride be heated close to a white-glazed vessel in a kiln, in the presence of a reducing atmosphere, the white glaze in the vicinity of the copper salt, vaporized by the heat, will be stained red by it. On Plate X (fig. 1) will be seen a section of an on-glaze copper-red vessel

and it will be seen that the appearance it presents is very different from the one shown on Plate VII, illustrating the in-glaze effect. It will be seen that the red band lies close to the surface with a colorless layer below it, but above the body, and that there is no sign of the other layers seen in the section of the in-glaze copper-red. There is considerable difficulty in persuading the colloidal, and vaporized, copper particles to spread themselves evenly on the glaze, but it is not necessary to go into that question since it is not a Chinese technique.

There are however two accidental cases of this effect which are worth recording as interesting examples. In the Chinese Exhibition of 1935 at Burlington House there were two dishes of Ju ware (Nos. 959 and 964) on which there were red suffusions attributed in the catalogue to the fact that the glaze had been "discolored by fire." This description was misleading as the fire was accidental and occured at the place where they were housed in 1923. Close to these dishes were bronze vessels and the surmise was made in 1935 that the red color was probably due to vaporization of copper which had been deposited as an on-glaze effect to form what is called a copper aerosol. Confirmation of this surmise was subsequently forthcoming as a result of an incendiary bomb during the London "blitz" in World War II. Some modern Japanese ash trays with a crackled blue-green glaze were subjected to heat caused by a conflagration in a warehouse. Some bronzes were also housed in the same

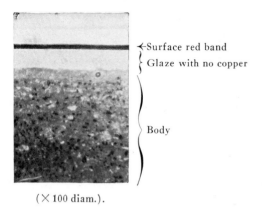

(× 100 diam.).

Plate X. (Fig. 1). Section of on-glaze reduced copper-red glaze.

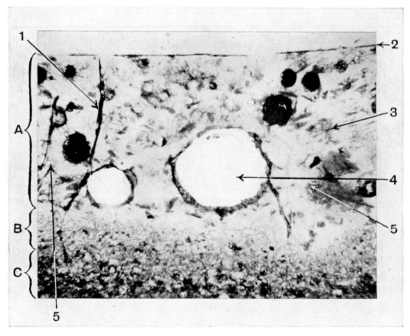

Plate X. (Fig. 2).
VERTICAL SECTION THROUGH REDDENED GLAZE

A. Glaze. B. Intermediate layer. C. Body.

1. Red color penetrating down cracks in glaze.
2. Thin red layer in upper surface of glaze.
3. Devitrification in the glaze.
4. Bubbles in the glaze with irregularly reddened inner surface.
5. Pale blue patches.

room close to the ash trays. After the fire was put out the glaze on the ash trays was found to have turned red. A section of the reddened glaze was cut and examined by Mr. W. Hugill and is reproduced on Plate X (fig. 2). It will be seen from the explanatory notes that a thin red layer lies in the upper surface of the glaze and microchemical analysis showed copper as present. The layer is much thinner than in fig. 1 as would be expected in the case of an accidental occurrence with a very small amount of vaporized copper in an unconfined space. Owing to the crackle of the glaze, the red color has penetrated to the full depth of the crazing and has also formed a layer on the surfaces of the bubbles in the glaze which were in contact with the craze lines.

The reader is probably familiar with the resplendent copper-red effects produced by certain well-known English potters today. These are achieved on similar lines. They are not in-glaze copper-reds such as the Chinese produced, but on-glaze effects.

If a copper-red glaze of this description were to be finished off in an oxidizing atmosphere, as the in-glaze effect is treated, the result would be that the colloidal copper particles would all be oxidized to cupric oxide and the result would be a white glaze next the body, as at the outset, and a surface glaze of faint green.

Peach-Bloom Glaze

Finally, in connection with the reduced copper glazes the famous Chinese peach-bloom effect

must be examined. Its general characteristics are well known, as are the prodigious prices demanded for fine specimens of it. The characteristics of the glaze comprise a soft pink effect with passages of deeper red color and green spots occur in many examples.

Recent researches by Dr. Mellor* have made clear what occurs. Prior to that investigation there was confusion in the minds of modern potters as to what was meant by the peach-bloom glaze. English potters deemed peach-bloom to be what the Chinese collector calls a form of flambé, which is commonly found. That effect has been described and explained as due to incipient devitrification of the glaze, causing opalescence. But Chinese connoisseurs mean by peach-bloom something very different and much more uncommon— hence no doubt the prices charged for fine specimens. A typical, or fairly typical, specimen is well known, viz. the water pot in the Salting collection at the Victoria and Albert Museum which is illustrated on Plate XI. There are passages of red merging into much fainter pink areas which have the palest shade of purple pervading them. In some specimens there are definite green spots scattered about in the glaze, but not in this particular example.

On Plate XII is shown another specimen of the glaze effect but of a much less beautiful character; it is a modern Japanese copy, though inscribed on the base is the *nien hao*

* "The Chemistry of the Chinese Copper-red Glazes, Part II." *Trans. Ceramic Society,* Vol. xxxv.

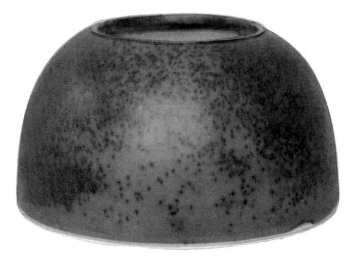

Plate XI. Peach-bloom water pot in the Victoria and Albert Museum.

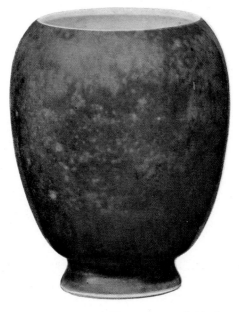

Plate XII. Modern peach-bloom vase, probably Japanese.

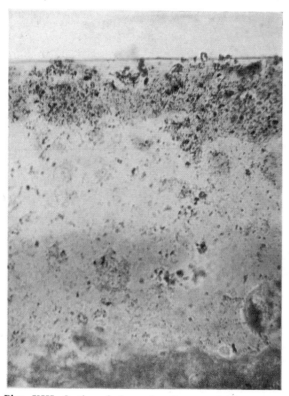

Plate XIII. Section of glaze of modern peach-bloom vase
shown in Plate XII.

of K'ang Hsi. It has a number of green spots in the glaze. The specimen is cut down because the neck was removed in order to furnish material for a section to be cut and examined. The section is illustrated on Plate XIII and was cut at a place where the pinky-red color was faint and the yellow color apparent. The section will be seen to consist of a yellow layer with patches of deeper yellow, lying above a blue band next to the body.

If this section is compared with that on Plate VII it will be seen that there are only two instead of five layers as shown in the other section—a yellow layer on the surface and a blue layer, consisting of the largest size of collodial copper particles, next to the body. All the rest of the reduced copper has been oxidized out and has lost its red color. In other words, the aerial oxygen has done its work fairly completely and all but converted the whole of the reduced copper into cupric oxide. The glaze is colorless because of the very small amount of copper present.

The yellow tint is due to a certain amount of iron being present which has been oxidized by the aerial oxygen into ferric oxide. In other (redder) parts of the glaze the amount of copper has been slightly greater and the aerial oxygen has had a stiffer task, so that it could not bleach out the red so completely.

The story thus far is only a slight variant on that of the sang-de-bœuf glaze, homogeneous in color to the eye. Putting it shortly, the copper in this variety of a copper-red glaze is

not evenly dispersed and various color effects are produced owing to the different amounts of copper present in contiguous sections of the glaze. A patchy effect is caused.

If a section had been cut through a portion of the Salting water pot at a place showing a bluish-pink, a film of red would be seen over the blue layer, causing the bluish-pink appearance. In that better example there is not sufficient iron to cause the yellow coloration. In some of the K'ang Hsi peach-blooms, passages of yellow-brown are found and these will be due to iron. The deeper red patches in the Salting water pot and in the Japanese reproduction represent the last stand made by the reduced copper to resist the onslaught of the aerial oxygen.

Green Spots on Peach-Bloom Glazes

The green spots still have to be explained. It is not uncommon to find minute globules of metallic copper segregated in a reduced copper glaze. By that is meant aggregations of dispersed collodial particles which are said to have flocculated. When the aerial oxygen gets at these tiny aggregates, it oxidizes them to cupric oxide which immediately dissolves in the glaze to produce the typical green color.

In other words, the green spots are produced by the oxidation of spots of metallic copper formed by the flocculation of the colloidal metallic particles. Examination of the modern example on Plate XII indicated spots which consisted partly of metallic copper and partly of cupric oxide—the intermediate stage.

There is little doubt that the peach-bloom effect was an accidental freak in the first instance, due to a chance more or less, or a mishap over a glaze which was intended to be a sang-de-bœuf. The Chinese potter, as usual, made use of his eyes and his brains. He, no doubt, tried to repeat the freak effect but found it difficult to get a result which was brought about by the coincidence of a number of factors, all operating at exactly the right moment. The "chanciness" of glaze effects is considerable, especially when as in this case the potter used a reducing atmosphere, followed by a certain amount, and only a certain amount, of oxidizing atmosphere subsequently. The most skilled potter in the world, even in K'ang Hsi's reign, could not count on producing this particular variant of a reduced copper glaze. The rarity of the specimens is evidence that this was so. Indeed, the modern example shown on Plate XII was not the result of mass production. The examination of this glaze effect from a scientific point of view furnishes yet another example of the enormous skill and profound mastery of potting technique possessed by the Chinese potter of the early eighteenth century. But even he could not do it often. If he had been able, connoisseurs would only pay the price they expect to pay for an ordinary piece of flambé.

It may be added that if a peach-bloom glaze were fired in an oxidizing atmosphere only—with no reduction—the result would have been faint green homogeneous glaze with

no green spots. If the glaze had been first fired in a reducing atmosphere and the subsequent oxidizing atmosphere had been allowed to operate long enough, the green spots would appear set in a pale green matrix. The reason why there would be no green spots set in a pale green matrix, if the glaze were fired in an oxidizing atmosphere throughout, is because there would be no collodial copper formed which could flocculate and furnish the necessary aggregations.

OTHER GLAZE EFFECTS

Cobalt Glazes

\mathcal{I}T REMAINS to consider certain other color effects. Most of them were the result of later efforts of the Chinese potter. Cobalt, however, was used from early times as a source of blue—quite a different blue from that derived from copper in Chinese glazes as a rule. But European potters produce blue glazes from copper, fortified with cobalt, which are difficult to distinguish from the pure glazes. The presence of cobalt can often be detected by shading the blue with the hand in daylight and then illuminating the glaze by artificial light. If cobalt is present, the color will appear darker.

In the T'ang dynasty, cobalt was used in a crude form to produce the blue glazed T'ang pots. It was used in later, pre-Ming, days to make the early examples of underglaze blue-and-white ware, and its use was enormously developed in the Ming and Manchu dynasties to form the well-known blue-and-white porcelains. The cobalt ore, finely divided, was painted on to the body in the required design and a colorless glaze was put over it; hence the term under-glaze. The finest mineral cobalt was derived from Persia and was known as Mohammedan blue. The refinement of the mineral from that source was a less

laborious task than the purification of the native article. But in the Manchu dynasty the native ore was refined to such a perfection that the blue-and-white of K'ang Hsi's reign is difficult to equal for brilliance of color. The process of refinement was costly in time and money.

There are, however, one or two qualifications to make on these remarks. Some of the old English potteries today, as Dr. Mellor* has pointed out, fail to reproduce as good cobalt blues as they did in olden days, using the old recipes worked under modern and improved methods. While the recipes are the same, the resulting blues are harsher and have lost their distinctive warm tone. The result is probably due to the greater efficiency with which the purification process has been conducted. The harsh tone was ameliorated by some small impurity which the potter of the past failed to eliminate. It is not improbable that the Mohammedan cobalt ore contained certain impurities which added to the effect, and that the Chinese ore contained other impurities which were deleterious. The efforts of the Manchu potters were directed to eliminate these deleterious impurities. We know that the Chinese cobalt blues contained a certain amount of manganese and also of ferric oxide and of cupric oxide.† Very likely the

* "Cobalt and Nickel Colors." *Trans. Ceramic Society,* Vol. xxxv.

† From work by J. J. Ebelmen and A. Salvétat. Later C. Lauth and G. Dutailly made good imitations of the Chinese cobalt blue from nitrates of aluminium, cobalt and manganese.

Mohammedan ore contained the right kind
of combination and could be used with success
without more elaboration.

A passing remark may also be made on the
K'ang Hsi blue-and-white porcelain. A well-
known characteristic of the ware is the fact
that the white has a beautiful ivory tone
resembling curdled milk, and this is as distinc-
tive almost as the sapphire blue which it
enhances in contrast. Students of old Delft
ware will also recall this feature. As has
already been shown, a minute quantity of iron
in a white glaze will impart a warm tone to it
when it is fired in an oxidizing atmosphere, by
turning the small amount of iron present into
ferric oxide. Quite probably the ivory tone of
the K'ang Hsi blue-and-white is due to the
presence of a minute quantity of iron and the
use of an oxidizing atmosphere to finish off the
firing. The main part of the firing would
need to have been done in a reducing atmos-
phere, and in the case of the Ming blue-and-
white, it is certain that a reducing atmosphere
was used throughout. But it is suggested that
in the reign of K'ang Hsi the added technique
of finishing with an oxidizing atmosphere may
have been employed. The reader will remem-
ber how an oxidizing atmosphere was used to
finish off the sang-de-bœuf glazes and the
same idea may have occurred to the K'ang Hsi
potters for their blue-and-white ware. The
definite addition of tin, which would produce
an opaque and curdled white, does not seem
necessary to account for the result.

Another minor point may be of interest. A well-recognized test of a genuine K'ang Hsi specimen of *famille verte* in which a cobalt-blue enamel is used is whether there is an "aura" in the contiguous white glaze—a film or iridescence bordering on the blue enamel. Some years ago an observant dealer noted this fact in the case of K'ang Hsi *famille verte,* and also observed that the "aura" was not present in the later specimens. The effect is produced by sulphate in the enamel glaze used, which, on decomposition by heat, produces sulphurous gases that attack the surrounding white glaze and cause deterioration of it. If a series of specimens of the occurrence is closely examined, it will be found that the "aura" is often prevalent in one direction, to the right or to the left. This would mean that the flow of the atmosphere in the kiln has been to the right or to the left, and that the sulphurous gases have been swept over the white glaze in that direction. Further, the cobalt enamel often shows on its surface what the modern potter calls "ironing," an opacity on the surface which has a rusty look. This is due to the cobalt being in excess and coming out of the solution on cooling, in much the same way as ferric oxide comes out of a solution supersaturated at the cooling temperature. Both appearances can be found in the cobalt enamels used in K'ang Hsi *famille verte.* It should not be difficult to produce the desired characteristics today! Such a suggestion may be disturbing, but comfort can be found in the

fact that the K'ang Hsi drawing has still to be matched.

Manganese Glazes

Manganese, except as an adventitious impurity, seems to have been first used as a coloring material in the Ming dynasty and the purple effects on the polychrome wares of that period are derived from this source. The metal is also responsible for the aubergine glazes which were specially exploited, as whole colors, in the latter part of the eighteenth century. Manganese oxide and cupric oxide have much in common from a chemical point of view, so far as glaze effects are concerned. In an ordinary glaze, manganese produces a brown color but will assume, and retain, a beautiful purple, if sufficient alkali is present. In that respect it has analogies with cupric oxide, which provides a turquoise blue when sufficient alkali is present. To get a rich purple color, it is necessary to hold the manganese by means of a sufficiency of alkali, and therein lies the difficulty. For, as in the case of the turquoise cupric-oxide glazes, the presence of too much alkali will make the glaze unstable and it will be readily susceptible to a humid atmosphere and deteriorate. At the same time, care must be taken to prevent volatilization of the alkali by undue raising of the temperature. The fine purple manganese glazes of the Ch'ien Lung period are achievements in this respect.

Mention has already been made of the use of manganese as an addition to produce, with

cobalt, an intense black, and its presence in much more minute quantities has been noted in connection with the underglaze blue.

Gold Glazes

More important, at all events from a chemical point of view, are the gold glazes. The whole of the *famille rose* wares owe their leading feature to the use of gold as a coloring material. Fortunately a very minute quantity of gold is required to give the necessary color effect. It has been estimated that a ruby-red glaze can be produced by one part of gold in 50,000 of the medium, and a rose-pink can be obtained by one part in 100,000. The way in which the gold acts is very similar to that in which the colloidal copper produces the sang-de-bœuf. Particles of colloidal gold account for the color in this case.

If a gold glass, with an appropriate amount of the metal in it, is raised to a high temperature, it will be transparent and free from color. As the temperature falls, the ruby-red will appear at a certain stage. If the temperature were gradually dropped further, the fine red color would go through stages of reddish-purple, blue, and finally a lighter blue color would be reached. The series of changes would be similar in character to those described in the case of a reduced copper glaze, which was colorless to start with, when rapidly cooled. The change in color would be found by microscopic examination to arise from the increasing size of the gold colloidal particles. By reflected light such a glass or glaze at the later

stages mentioned will show a cloudy brown
or bronze appearance due to reflection from
minute globules of gold, and many specimens
of *famille rose* show this bronze appearance
on the top of the red color. While the rose-
pink and ruby gold effects are well known, the
reddish-purple color is uncommon; but speci-
mens of it can be found in modern Japanese
potting of great excellence.

The purple of Cassius is produced from a
mixture of gold with tin, and some of the later
purple glazes of the Chinese may have been
achieved by this means.

Opalescence

Opalescence in a glass or glaze plays an impor-
tant rôle in many Chinese ceramic effects and
reference to the fact has been made inciden-
tally in an earlier chapter. It is necessary to
say more. An opal glass when very hot and
nearly fused is quite as clear as any transparent
glass at the same temperature. But as the opal
cools it becomes cloudy, owing to the separa-
tion in it of minute globules of material which
are more soluble in the hot glass than they are
in the cold one. The material that separates
out may be silica, in which case delicate opal-
escent blues are generally obtained by reflected
light. Or the separated materials may be
phosphates of lead or calcium, or of iron and
copper, to mention likely sources of opalesc-
ence-producing materials found in Chinese
glazes. If these minute globules of separated
material are densely aggregated and substan-
tial in size, a definite opaque appearance is

caused by reflected light. They appear brown
by transmitted light. If an opal glass, which
is quite colorless owing to the fact that it has
been cooled quickly from a high temperature,
so that the separation has been arrested at an
early stage owing to the high viscosity reached,
be reheated, such a glass, at temperatures vary-
ing with the amount and insolubility of the
opal-forming material, will become cloudy,
and as the cooling proceeds the opalescence
will become more pronounced, until opacity is
reached. Opalescence in a glass will therefore
give a series of color effects which vary from
a dense white, through shades of pearly luster
to a cloudy blue. Evidence of these color
effects can be found in the Chinese glazes, and
the Kuang-tung glazes are good examples. The
reader will recall how, in examples of the
Cantonese potters' work, variegated colors
with streaks of opalescence or opaque white
running through them are not uncommon.
Considerable amounts of phosphate are to be
found in these glazes and it is easy to under-
stand how the results came about. Less-
marked evidence of dense opalescence can be
found in other wares, and reference to the
Chün wares in this connection has already
been made. A good deal of the white appear-
ance of the Ting yao is due to opalescence, or
at all events is enhanced by its presence. Opal-
escence also plays an important part in the
flambé wares. The pearly-white and bluish-
white fleckings which appear in a red or purple
main glaze are instances, and explanation has

been furnished of the way in which incipient devitrification of the glaze and the formation of tiny crystals will cause this opalescence (*vide* Plate VIII). In many Chinese glazes, produced in a variety of ceramic centers, opalescence plays some part in producing or modifying the final effect. The definite presence of a phosphate seems only necessary where a very opaque white opalescence has to be explained; the less dense forms, i.e. the pearly-white appearance and the bluish-opal effect, can be brought about without the presence of any powerful opacifying agent.

Crackle

Crackle has always been regarded as one of the special and popular features of Chinese porcelain. It furnishes another instance of the clever way in which the Chinese potter used an annoying defect as a means of adding an artistic feature. The crazing of pottery and porcelain ware is a perpetual source of trouble to the European potter and he does not do it intentionally, though the Copenhagen potters use this technique for their crackle effects. Many of the Chinese potters made a habit of it: in fact in Sung days Chang the Elder made his reputation by it, and Ko ware named after him owes its most distinctive feature to a crackled or crazed glaze. The Chinese potter did not wait until some adventitious colored fluid percolated into the crazings of his glaze to draw attention to their presence. The modern white jug tells its tale *after* the jug has left the potter's factory, when coffee has been left

standing in it a number of times. The Chinese potter colored his crazings as part of his work, and moreover controlled the crazing so as to make a wide or fine mesh at will. The reader will be familiar with crackle which varies in size of mesh from that of a fishing net to what has been called "truité" or fish-roe crackle.

To what is crazing or crackle due, apart from its accentuation by the addition of coloring material in the cracks which cause it? The leading consideration depends upon the fact that when moisture is driven off from a plastic or semi-plastic material it shrinks and may not do so uniformly. If a piece of unseasoned wood, i.e. wood with a fairly high moisture content, is put in a warm place, it cracks. If a mud bank is exposed to the sun, it cracks, and the fissures may be large. A crevasse is an example of the same thing on a still larger scale. The cracking process would take place more readily, if two materials, one on top of the other, had different rates of contraction. If two materials were fused together and they contracted at different rates, one of them would have to give after a certain tension had been reached. In very general terms this is what occurs in the crazing of a glaze. The potter often speaks of a glaze "fitting" the body: by that he means that the ratios of contraction of the two materials are sufficiently similar to give rise to no subsequent trouble in regard to crazing.

If the ratio of contraction of the body and glaze is not similar (it is never identical), the

glaze or the body has to give on cooling. It will be clear that by altering the glaze and the body, it would be possible to bring about a marked difference in the ratio of contraction and produce cracking to greater or less extent. The rubbing-in of some coloring material would be a simple matter to bring out the fact that fissuring of a glaze had occurred.

But crazing and the factors that lead to it are not quite so simple as that, though the broad reason is as stated. The question has been dealt with at length by Dr. Mellor.* The following are the leading features to which he draws attention and those which are perhaps of the most interest in connection with the Chinese wares. The amount of expansion on heating, and subsequent contraction on cooling, will vary in different bodies and in different glazes. The expansion and contraction of a body may be greater than that of the glaze or *vice versa*. If what is called the coefficient of expansion of the glaze is greater than that of the body, stress between body and glaze will occur; and if the strength of the glaze or of the body is not sufficient to stand the strain, something will happen. The glaze may crack or craze. The glaze may be strong enough to resist cracking and may bend the body or even break it, if it is thin and weak. Or the glaze may be torn off at the juncture of glaze and body.

* "Crazing and Peeling of Glazes." *Trans. Ceramic Society,* Vol. xxxiv.

If on the other hand the coefficient of expansion of the body is greater than that of the glaze, then if the strength of the glaze and of the body is not sufficient to stand the strain, the glaze may peel from the body at the edges; the body may bend in the opposite direction or be ruptured. Or the glaze may again be ripped off at the junction of glaze and body in a more pronounced form of peeling.

While examples of crazing or crackle are common enough, cases of peeling are less frequent in Chinese glazes; but in some of the Manchu enamelled glazes, instances can be found where a secondary enamel glaze appears to have chipped off in places, an occurrence due to this process of peeling. The two diseases from a potter's point of view are difficult to diagnose, as the ultimate visual result is often similar, owing to crazing being produced as a result of peeling. There is a large number of other subsidiary factors which have to be taken into account when crazing (or peeling) is to be diagnosed; mention need only be made of one or two.

It will be understood that there is a certain elasticity in the glaze and in the body; and this will operate, when the strain between body and glaze is present, to hinder or accelerate the crazing effect. The rate of cooling of a glaze has an important influence on this elasticity of a glaze in tension, and the process of annealing of a glass, to relieve the strains set up, is a familiar example of this fact. If instead of annealing a glass or glaze the op-

posite process were employed, the glass or glaze could be crazed on purpose by admitting a cold blast of air into the kiln at the appropriate time. This process was undoubtedly followed by the Chinese potter to help his crackle effects.

From what has been said earlier it will be realized that the acidity or alkalinity of a glaze affects its viscosity, and will play a part in the resistance of a glaze to these stresses, especially when a thick viscous glaze is in question.

Another subsidiary factor may perhaps be mentioned and that is the effect of the corrosion of a body by a glaze at the point of juncture. Some of the reduced Chinese glazes had a very definite dissolving effect on the body. The reduced copper sang-de-bœuf glaze is a case in point. This process of erosion will also modify the strains set up and the degree to which crazing is caused. The reader will recall the observation made about the relative amount of crazing to be found in the red portion of a sang-de-bœuf glaze and in any white portion of it.

Double Crackle

There is, however, a form of crazing that needs closer attention from a collector's point of view, and that is what may be called delayed crazing, arising from the seasoning or ageing of a glaze. The final contraction of a glaze may take months or years for completion and this delayed contraction may result in a secondary crazing effect, over and above the original crazing, or as the sole expression of

a return to equilibrium on the part of the glaze and body. Many of the Chinese wares have a definite and stained crackle, but, in addition, other crackle lines which are not stained. Moreover, in the Manchu dynasty in particular, there are plenty of examples of crackled ware in which the lines of the crackle have two different colors, one generally black and the other light brown. An example is shown on Plate XIV. This effect can be attributed to this process of delayed contraction of a glaze. It is not difficult to imagine the potter, having achieved his original crackle on the initial firing of his ware, staining the pronounced crackle with a suitable coloring material which would fill the crevices. He would have his dish or pot with a well-defined and widely spaced ice-crackle decoration. He might then leave the pot for a while to settle down, so to speak, and develop its final or further crazing. The time taken to complete this secondary contraction would depend on the nature of the glaze and of the body. It might take weeks, months or years. As soon however as there was sufficient additional crazing brought about, he could bring out the new lines by rubbing in a different color. Indeed, it might be possible to obtain a three-color crackle in this manner.

This ageing crackle effect is not unimportant from a connoisseur's point of view. Many have been confronted with modern productions of T'ang ware. These modern imitations are often free from crazing or the craze lines

Plate XIV. Vase showing double crackle.

are fairly widely spaced. The types of glaze used (as in the case of the T'ang examples) do not craze very readily. The ratio of contraction between the body and glaze is not sufficiently dissimilar, and these easily fusible glazes are less liable to craze than the less fusible and more acid glazes, on stoneware or pottery bodies. As time went on, however, the age crackle developed, assisted no doubt by deteriorating influences; and all authentic T'ang specimens, it is not perhaps rash to say, show a close network of craze lines in the glaze, when viewed under a lens. The modern reproductions, as a rule, do not do so.

Disintegration of Glazes

So many of the early Chinese ceramic vessels have been preserved by Mother Earth through burial as mortuary wares, and subjected in consequence to deteriorating influences, that it may be useful to say something about the disintegration and degradation of glazes. The word disintegration is here used to imply changes which have occurred in a glaze which are not visible to the unaided eye or even with the help of a microscope; and the word degradation to imply a stage when disintegration has proceeded sufficiently for it to be observed with the eye. To make the distinction more obvious, it may be explained that a piece of glass tubing which has been exposed to the atmosphere for a long period may look perfectly sound, however close the inspection; but if it is placed in a flame, it will break up and flake away. Some good glass tubing has been

known to display no defect after fifty years' exposure and some displays disintegration under trial by fire after ten years' exposure. A bad piece of glass tubing may fail after one year. Generally speaking, a piece of glass tubing exposed for twenty years suffers disintegration to a depth from the surface of about 1/500th of an inch. If such tubing were exposed for centuries it would be completely disintegrated and the degradation to be observed would be as marked as that visible in ancient Roman and Egyptian iridescent glass. In general, soft glasses of the sodium-calcium-silicate type with a fairly high proportion of alkali are more prone to disintegration than hard glasses of the same type containing less alkali. Again, lead glasses are less liable to disintegrate than those without lead in them.

Four broad generalizations may be made: (1) no glazes at present known can be called permanent in the ordinary atmosphere; (2) disintegration of some of the most stable kinds of glaze may be so slight that even after centuries of exposure no visible degradation can be observed; (3) lead glazes are more stable than soft felspathic glazes; and (4) the hard felspathic glazes, made at high temperatures, can resist disintegrating influences to such an extent that after centuries of exposure they may show no visible degradation.

Iridescence

Microscopic examination of lead-silicate glazes of the T'ang dynasty has shown that degradation takes the form of the separation

of thin layer after layer of the glaze, and it is this layering that produces the familiar iridescent effect. The luster effect on certain ceramic wares is another instance of the result of layering. The iridescent sheen caused by a film of oil upon water is yet another example of the same thing.

It may be observed that in the case of the T'ang green and yellow glazed wares that have been degraded through burial, and subjected in consequence to deteriorating influences, the iridescence is confined to, or is much more pronounced upon, the green glaze than on the yellow part. As we have seen, the green on those T'ang wares is derived from cupric oxide and the yellow from ferric oxide. The stability of the iron glaze is greater than that of the copper glaze, provided the other constituents are similar. As a result, disintegration to the extent of degradation is apparent in the green portion but invisible disintegration only has occurred in the yellow areas. But caution must be observed in drawing too hasty conclusions from the absence of obvious degradation on a glaze; so much depends upon the influences which have operated. It is quite possible for two pieces of pottery or porcelain, one visibly degraded and the other apparently showing no disintegration, to have been made at the same time and in the same furnace. Difference in their original position in the furnace causing variations in the temperature to which they were subjected; difference in the humidity of the atmosphere to which the glazes

have been subsequently exposed; difference
in the changes of atmosphere which may have
occurred during their preservation with the
result that in one case there have been long
periods in which the glaze was kept dry and
in another there has been persistent attack by
water; all these factors would affect the de-
gree to which the glaze showed degradation.

It will be understood that the foregoing re-
marks apply, so far as iridescence is concerned,
to the effects of weathering. Iridescence on a
glaze can be induced by the use of bismuth
salts to produce a luster effect and a whiff of
smoke introduced as the firing nears comple-
tion would also give an iridescent sheen to a
glaze newly made. Some of the eighteenth-
century glazes, e.g. the green copper glazes,
due to cupric oxide, have an iridescent sheen
which is probably due to this slight addition
of a reducing atmosphere at the close of the
firing or to a slow attack by aerial oxygen at
ordinary temperatures, as happens in some
modern tile glazes.

Another important factor may be noted;
and that is the presence of dust. Particles of
dust, acting as nuclei round which infinitesi-
mal droplets of water can form, seem to retain
moisture a long time on a glaze. If therefore
two similarly glazed pots are placed, one in
a dusty place and the other in a quiet atmos-
phere, comparatively free from dust, it would
be confidently expected that signs of degrada-
tion would appear first on the pot which had
been exposed to the dusty atmosphere.

Roughness on the glazed surface and inden-
tations arising from the contour of the design
of a pot are also places where the process of
disintegration find scope for development.
Collectors will be able to recall specimens
where the effects of decomposition are more
apparent in interstices, and where iridescence
is more in evidence on a roughened surface.
Such positions lend themselves to the persis-
tent action of moisture.

So far most of what has been said about the
disintegration and degradation of glazes ap-
plies chiefly to the softer and earlier glazes of
pre-Sung date. The same observations apply
to the Ming wares in which a similar type of
glaze was employed; in these the deteriorating
influences have however been at work a shorter
time, and also have not been so drastic in their
nature. Most, if not all, of the pre-Sung wares
with which we have come into contact have
been buried in the ground or at all events
stored away in caverns or caves in humid sur-
roundings. The Ming wares have come to us
from above-ground sources as a rule.

The Sung wares as a whole show very little
evidence of disintegration to the eye, because
the high-fired felspathic glazes of that period
were very resistant to change. That some
chemical disintegration has taken place can be
traced in certain instances, but many look as
fresh today as they must have looked when
turned out of the kiln. Fragments of vessels
with this type of glaze which have been buried
for long periods show little or no sign of glaze

deterioration, especially if they have been buried in dry ground. Perhaps the least evidence of disintegration is found on the wares of the temmoku family. Mention has been made of the fact that the yellow iron glazes on the T'ang mortuary wares are always in a better state of preservation than the green copper glazes.

The felspathic glazes with ferric oxide for their coloring material are very stable and more so than the softer glazes with the same oxide in them. It will be remembered that ferric oxide goes into combination with alkali to form a yellow glaze and becomes dispersed to form dark brown and black glazes when less alkali is present. Ferric oxide has a considerable attraction for alkali and secures a firm grip upon it in a glaze, though its attraction to silica is even greater; consequently there is less opportunity for the alkali to become acted upon by external chemical influences. The intimacy with the ferrous oxide in the celadon glazes is less close, and the alkali is more readily affected. In the Northern Chinese celadons, there is a certain amount of ferric oxide present, in addition to the ferrous oxide, and this probably accounts for the greater stability of this branch of the celadons.

Bubbles in Glazes

It may be appropriate to say something about bubbles in a glaze and the way they are caused, without entering into the controversy about Kuan and Ko ware and the notion that Ko ware has bubbles and Kuan has none. The dis-

tinction is somewhat difficult from a scientific point of view and has not reached a stage beyond that of lighthearted suggestion. Certain facts can, however, be stated on the causation of bubbles in a glaze. "Spit out," blistering and pin-holes are constant sources of trouble to the European potter and much has been written about them. All these varieties of the same thing are caused by bubbles of gas bursting on the surface of a glaze, marring its even, smooth surface. Various agencies may operate to produce bubbles and cause blistering or pitting of the glaze surface. The chief causes are as follows: The presence of unburned carbon in the body in the form of minute particles which unite with oxygen in the atmosphere of the kiln to produce carbon dioxide; that gas, moreover, would be produced under considerable pressure so that it explodes, causing a rupture. Bubbles may also be formed from moisture left in the body or from hydrocarbons in the body. In such cases the bubbles will be of steam or a hydrocarbon gas. These are all causes of bubbles arising from the body. Bubbles may also be formed from the same sources, carbon, water or hydrocarbons, in the glaze itself, and it is probably from such impurities in the glaze mixture that most of the bubbles in the Chinese wares are due. Mention has already been made of the pores to be found in certain iron phosphatic glazes, e.g. the Chün yao, arising from the formation of phosphoric oxide (P_2O_5). It follows from what has been said previously

that bubbles are to be found more often in a thick, viscous glaze than in a more fusible and thinner one. The greater fluidity of the more fusible glaze when molten would allow bubbles, formed from the causes named, to rise to the surface and dissipate themselves. In the viscous Sung glazes they cannot escape so easily and hosts of them remain imprisoned.

Polishing of Glazes

Reference has already been made (p. 12) to the scattering of light from a scratched glazed surface and to the "ground glass" effect caused thereby. A scratched glazed surface can be restored by means other than the smoothing down of the tiny hills and valleys there described. If the glaze is thick enough it can be "reflowed." The subject of scientific polishing has been explored by the late Sir George Beilby, F.R.S., who in 1921 published the results of his researches, with which Mr. W. D. Haigh was associated.* The theory as enunciated by Beilby may be stated thus. The surface of a solid, under suitable conditions of pressure and drag, can be made to flow at *ordinary* temperatures. The depth of this flowed surface-layer will vary with the hardness of the material and may range from a few molecules of thickness in very hard materials such as some metals to several hundred molecules in softer materials. The necessary drag is brought about by a suitable powder in a very fine state of division on a rubber such as pitch, felt or

* The Aggregation and Flow of Solids.

wash leather. The powder serves to make the
contact between the rubber and the surface to
be polished as intimate as possible.

As soon as the surface of the glaze to the
very slight depth indicated is made to flow by
the application of the rubber, surface tension
operates. Surface tension may be explained
simply thus. All liquids form on their surfaces
a thin but stretched elastic layer which tends
to constrict that surface and to convert the
liquid into a round mass enclosed in an en-
velope. If the mass of the liquid is great, the
force of gravity, being stronger than the force
of surface tension, flattens the surface. But if
the mass of the liquid is small then the force
of surface tension tends to make the surface
convex, and if the mass is small enough to con-
vert the liquid into drops. Raindrops, dew
drops, oil drops and drops of molten glaze are
all examples of the effect of surface tension
while mercury droplets are the best examples
of all.

The superficial layer of glaze, brought into
a fluid condition by the action of the rubber
impregnated with rouge powder, retains its
mobility for an instant and in that instant sur-
face tension operates to produce the liquid-like
surface which is the condition of a perfect
polish.

These principles were applied by Mr.
Haigh to a waterpot with a sang-de-bœuf
glaze produced in the way described on p. 61.
The relatively thick and colorless superficial
layer of the glaze had been very badly

scratched and disfigured by ill usage or accident. As a result of the polishing treatment the surface was reflowed and the scratching obliterated. The procedure was analogous to the restoration to a picture and the glaze was restored to the condition in which the eighteenth century potter had left it. The specimen is illustrated and described in the Transactions of the Oriental Ceramic Society, Vol. 19, pp. 49-51.

Cleaning

It may be useful to add a note on the best way to clean porcelain, especially delicate specimens with reticulations, or Fukien figures. Attempts with soap and a toothbrush often lead to disaster. The following method, *provided the specimen has not been mended,* gives excellent results. Acquire some oleic acid and some household ammonia. Fill a bowl, sufficient in size to take the specimen, with water. Pour some oleic acid on to its surface when the fatty acid will float on it in globules. Add the ammonia until there is a faint smell of ammonia. Then whisk up the mixture until a frothy solution of ammonium oleate is produced. If the solution does not froth properly, add some more oleic acid. Place the specimen in the soap solution for several hours, remove it and put it under the water tap. All the dirt will wash away. The soap solution will have loosened the dirt particles in the crevices which the stream of water removes. If the specimen has been mended, the soaking process will naturally soften the adhesive.

Specific Gravity and X-Ray Analysis

A short reference to an enquiry with a some-
what negative result that was investigated
through the instrumentality of Sir Percival
David needs to be recorded. The theory ad-
vanced was that it might be possible to differ-
entiate between the twelfth-century wares and
the similar reproductions of them made in the
eighteenth century by testing the specific
gravity of the respective bodies. It was not a
very promising business for several reasons;
one was that there are bound to be gas inclu-
sions in the body and in the glaze: the presence
of these would affect the specific gravity and
it would not be possible in consequence to
ascertain what was the true specific gravity of
the body and glaze material. Moreover, it was
obviously impossible to strip the glaze without
destroying the specimen. This difficulty could
be got over by the use of excavated fragments
of which a quantity was available. The issues
were discussed with the authorities at the
National Physical Laboratory and it was de-
cided to conduct certain investigations into the
specific gravity question, and that an analysis
by X-ray treatment should also be attempted.
The Laboratory's report was authoritative and
exhaustive. The specific gravity determina-
tions led to nothing. The tables of comparison
of tests of a number of specimens of widely
different dates, twelfth to twentieth century,
showed but little indication of a systematic
change between one century and another. The
investigations proved that this method was not

going to be a source of information on attributions. The initial X-ray examination appeared more promising. Two specimens of fragments from a Hang-chou site gave identical X-ray patterns and so did two specimens from Honan sites, while the Hang-chou and Honan X-ray patterns were different from each other. This preliminary report encouraged further enquiry on a much larger scale and a considerable number of fragments were subjected to examination in this fashion. The conclusions of the Laboratory report are as follows: "A study of the diffraction patterns given by the various specimens examined shows that the structure of the material underlying the glazed surfaces varies considerably from specimen to specimen. There are, in general, two crystalline constituents but the relative amounts of these constituents can vary within wide limits. These differences did not occur among specimens from the same source, which were found to give identical diffraction patterns. When, however, the source of the specimens was varied, the differences referred to made their appearance. It was only possible to examine two of the later period specimens, but these were found to have a structure generally similar to the older specimens. It would appear, therefore, that the observed differences arise from differences in the composition of the clays used for the manufacture, and that this composition varied from district to district. The general similarity of the later period to those in the older specimens suggests that the

process of manufacture used at later times was not sufficiently different from the older method to cause any structural difference in the clay. As far as can be deduced from these experiments, the X-ray diffraction method does not hold out any hope of being useful as a means of determining the dates of the specimens, but in favorable circumstances might serve as some indication of the general source of the raw material used in the manufacture of the wares." Such is the conclusion reached and while it is disappointing in a way, there is satisfaction in the knowledge that the enquiry has been made with all possible scientific skill, and collectors are indebted to Sir Percival David for having had the work done and the necessary record made.

Conclusion

The scientific aspect of several Chinese glaze effects has been omitted; but for the purpose of the lectures on which this book is based, it was not possible to deal with more than a limited range; and concentration has been made on the chief aspects only of the subject. Many of the features of the glazes which have not been discussed will be explainable, however, in the light of the principles outlined herein.

It is not inappropriate to close by repeating the statement that the closer the examination of these glaze effects is conducted the more profound must be the admiration excited in regard to the technical skill displayed by the Chinese potter.

An interesting comment has been made by
Dr. Mellor in describing a joint research con-
ducted by Mr. Bernard Moore and himself—
a powerful combination of a very skilled
potter and a distinguished man of science. Dr.
Mellor writes: "Naturally I wanted to deal
with the problem in one way and he in an-
other, we therefore agreed to go our own ways
and to link up later on. I wanted to examine
all possibilities, ultimately rejecting those
which appeared to lead in unprofitable direc-
tions. I anticipated that my friend's method
would furnish what the mathematician calls
a *specific* solution of the problem, and that
the more elaborate procedure would give a
general solution. Mr. Moore worked in his
own way. I was very interested as a spectator.
I was amazed at the unerring instinct dis-
played by my friend. Like a bloodhound on a
fresh trail, he rapidly went ahead, and in my
opinion he arrived at a successful solution of
the problem in a very short time—excepting,
of course, for the clean-up of a few loose ends.
He was well on the way to the winning post
before I was ready to start. I can see J. F.
Böttger proceeding in a similar manner in
researches which culminated in his discovery
of the secret of manufacturing Chinese porce-
lain, in Europe, in 1709. Once or twice I was
wicked enough to wish that something would
go radically wrong with Moore's work so that
I could observe how he would pick up the lost
trail, but unluckily (!) he had no real set-

backs. The research in his hands went remark-
ably smoothly."

These comments are illuminating, and very
probably the same would be said if a man
versed in all the science of today could be
coupled with a Chinese potter of a few cen-
turies ago. It is also probable that the man of
science would add to his knowledge more than
the Chinese potter would add to his under-
standing of the business.

SELECTED BIBLIOGRAPHY

The references given as footnotes to the text furnish the chief sources of information from a scientific point of view. The papers written by Dr. Mellor which are contained in the *Transactions of the Ceramic Society,* and quoted in the footnotes, have complete bibliographies appended to them.

The following is a short list of books on Chinese ceramics in which can be found accounts of the wares dealt with herein from a general or ceramic point of view:

BURTON, W. *Porcelain; a Sketch of its Nature, Art and Manufacture.* London, 1906.

BUSHELL, S. W. *Chinese Art.* Victoria and Albert Museum Handbook. 1906.

——*Description of Chinese Pottery and Porcelain, being a Translation of the T'ao Shuo.* Oxford, 1910.

HANNOVER, EMIL. *Pottery and Porcelain,* translated from the Danish. Edited by BERNARD RACKHAM. London, 1925.

HETHERINGTON, A. L. *The Pottery and Porcelain Factories of China* (map). London, 1921.

——*The Early Ceramic Wares of China.* London, 1922.

HOBSON, R. L. *Chinese Pottery and Porcelain.* London, 1915.

——*The Wares of the Ming Dynasty.* London, 1923.

——*Guide to Pottery and Porcelain of the Far East in the British Museum.* 1924.

——*The Later Ceramic Wares of China.* London, 1924.

——*A Catalogue of Chinese Pottery and Porcelain in the Collection of Sir Percival David.* London, 1934.

HOBSON, R. L., and HETHERINGTON, A. L. *The Art of the Chinese Potter.* London, 1923.

HONEY, W. B. *Ceramic Art of China.* London, 1946.

International Exhibition of Chinese Art, Catalogue of. London, 1935.

JULIEN, STANISLAS. *Histoire et Fabrication de la Porcelaine Chinoise.* Paris, 1856.

GLOSSARY

List of dynasties referred to herein with some comparative dates.

Han dynasty 206 B.C.-A.D. 220 ·	Destruction of Carthage, 146 B.C. Julius Caesar first landed in Britain, 55 B.C. Marcus Aurelius, Roman Emperor, A.D. 161
T'ang dynasty 618-906	Mohammed died, 632 Charlemagne crowned, 800 Alfred the Great, 871-901
Sung dynasty 960-1279	Voyage of Leif Ericsson to Vinland (N. America), 999 Magna Carta, 1215
Mongol dynasty 1280-1368	Marco Polo first reached China, 1275 Dante, 1265-1321
Ming dynasty 1368-1644	Chaucer, 1340-1400 Columbus discovered America, 1492 Armada, 1588 Foundation of Virginia, 1608 Voyage of Mayflower, 1620
Manchu dynasty 1644-1912	Settlement of Georgia, 1733 Declaration of Independence, 1776 Convention of Philadelphia, 1787 Birth of Abraham Lincoln, 1809

The following explanation of terms used, and names mentioned, may be useful to readers who are not familiar with the subject of Chinese ceramics:

Celadon. Derived from *Saladin,* Sultan of Egypt who sent forty pieces of the ware to Nur-ed-din, Sultan of Damascus in 1171. Another derivation is from the shepherd Céladon, a character in a seventeenth-century romance called *L'Astrée,* written by Honoré d'Urfé. The shepherd was garbed in a grey-green coat of a distinctive tone.

Chang. The name of the two famous potters of the Sung dynasty who worked at Lung-ch'üan in the province of Chêkiang. Ko means the elder brother and Ko ware is named after the elder Chang: the younger brother made the typical celadon ware of that period.

Chi-chou. in the province of Kiangsi: little is known of the ware made in the potteries here, which were operating in the Sung dynasty.

Ching-tê Chên. The ceramic metropolis of China from the beginning of the Ming dynasty: it is in the province of Kiangsi. At the height of its fame a million persons were said to be employed there. Its products were taken to Nanking for shipment abroad; hence the term Nanking porcelain.

Ch'u-chou. A pottery where celadon porcelain was made in the Ming dynasty; it was near Lung-ch'üan in the province of Chêkiang.

Chün Chou [modern name **Yu Chou**]. The center of important potteries in the province of Honan which were operated in the Sung and Ming dynasties. The ware is divided into two categories, "hard" Chün and "soft" Chün, the distinction applying to the kind of body used. The glaze varies from a lavender-grey to an opalescent blue and often has splashes of reddish-purple. The bulb bowls and flower pots are particularly gorgeous with their flambé effect.

Père d'Entrecolles. A famous Jesuit priest who lived at Ching-tê Chên in the reign of K'ang Hsi during the Manchu dynasty. His letters dated 1712 and 1722 furnish important contemporary evidence of the potting technique used.

Famille verte and Famille rose. Categories of enamel-glazed porcelain made in the Manchu dynasty which owe their names respectively to the predominance of green or pink-colored decoration.

Flambé. A term used to describe a glaze with streaks of red, reddish-purple or blue interspersed in a groundwork of more homogeneous color, producing a flame-like effect.

Hang-chou. The capital in the latter part of the Sung dynasty, where the Imperial or Kuan ware was made of that date. It is in the province of Chêkiang.

Hare's fur glaze. A term used to describe the streaking of brown in a surrounding black glaze which was thought to resemble the fur of a hare. See also *Temmoku*.

Honan. A central province of China, where several important potteries existed in the Sung dynasty.

Ju Chou. A town in the province of Honan where a famous ware was made in the Sung dynasty, which has not yet been authoritatively identified.

Kinuta is Japanese for a mallet, and the term is applied to a type of bluish-grey celadon. A famous vase with such a glaze was made in the shape of a mallet.

Ko yao. The ware made by the elder Chang which has, as its most distinctive feature, a stained crackle. See also *Chang*.

Kuan yao. The term means "Imperial ware" and signified a product made for Imperial use: it has come to be applied to a type of ware made first at K'ai-fêng in Honan in the early part

of the Sung dynasty, and at Hang-chou in the latter part of that dynasty. It has a greenish-grey glaze and has a close resemblance to Ko yao.

Kuang-tung. A province of China in the South, of which the capital town is Canton. A number of potteries operated in this area from the T'ang dynasty onwards.

Lang yao. Ware deriving its name possibly from the family of potters who perfected the technique of its production. The term is especially connected with the fine specimens of sang-de-bœuf glaze made in the reign of K'ang Hsi. There are other derivations of the term, e.g. from Lang T'ing-Chi, a governor of Kiangsi in the early part of the 18th century.

Lung-ch'üan. A pottery center in the province of Chêkiang where the celadon ware of the Sung dynasty was largely produced. See also *Chang.*

Mohammedan blue. A term applied to the cobalt ore imported into China largely from Persia during the Ming dynasty for making the underglaze blue ware.

Nien hao. The name of a period in the reign of a Chinese Emperor written on the vessel, generally in underglaze blue on the base, to signify the approximate date of the piece, or the style in which the design had been executed. The *nien hao* is not to be taken as satisfactory evidence of the date of the specimen nor is it to be regarded as an intentional fraud when obviously incorrect. The *nien hao* of a past Emperor was sometimes added because the decoration conformed with the style prevalent in the reign of the Emperor designated.

Saggar. The protective case in which the porcelain was placed to prevent the flames having direct access to it. The name is derived from "safeguard."

Samarra. The town of Samarra on the Tigris was founded in A.D. 838 and was abandoned and fell into ruins in A.D. 883. The site was excavated in 1914 and fragments of Chinese porcelain were discovered in the ruins which have proved valuable archaeological records for dating certain Chinese wares.

Sang-de-bœuf. The red ox-blood glaze derived from reduced copper. See also *Lang yao.*

Temmoku. Temmoku bowls were tea bowls which probably derived their name from the fact that a bowl of Chinese origin was brought to Japan during the Sung period by a Zen priest from the Zen temple on the T'ien-mu Shan, or the "Eye of Heaven" mountain, in the north-west of Chêkiang. In Japanese T'ien-mu Shan becomes Temmoku-zan. The name has become still more widely applied to ware of the type, whether tea bowls or not.

Ting Chou. A town in the province of Hopei where, as a rule, white ware was made in the Sung dynasty. The literature also

refers to other colored ware from these potteries which was black and also brown. The white ware has "tear drops," i.e. drops of glaze which have formed as the glaze has flowed down the vessel.

Tobi seiji is the Japanese term for "spotted celadon." The kinuta celadon is known as *Kinuta seiji*.

T'ung. The god of the potters (the Genius of Fire and Blast), derived from the legend that a potter in the reign of Wan Li (1573-1619) threw himself into his kiln in despair of executing an Imperial order for a particular glaze effect: the legend records that the desired result was miraculously achieved in consequence.

Tz'ŭ Chou. A town in the province of Hopei which has been a pottery center for thirteen hundred years. The name means "crockery town." The main part of the ware produced comprised vessels with contrasting decoration of black and white; but black and brown glazed ware was also made.

Ying-ch'ing. The terms means "shadowy blue (or green)" and is used to describe a highly translucent and thinly potted porcelian dating from the Sung dynasty which has a faint blue color where the glaze is thick. The same type of glaze is found on different, and thicker bodies.

INDEX